CW00459995

Women of Substance

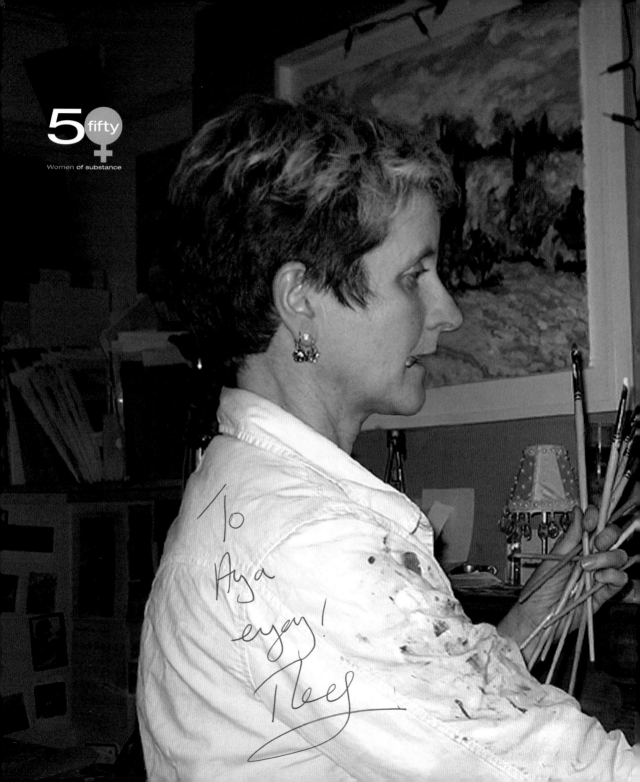

Women of Substance

50 PORTRAITS OF HIGH PROFILE WOMEN OF OUR TIMES

Tess Barnes

For Mark Emma and Izzy

Originally published in
Great Britain in 2008
Copyright © Tess Barnes 2008
The moral right of the author has been asserted.

A CIP catalogue record for this book
is available from the British Library.
978-0-9558104-0-4

Designed in Adobe InDesign CS3
and typeset in Adobe Garamond Premier Pro
by Rick Fawcett.
Printed and bound by Graphicom, Vicenza, Italy.

www.tessbarnes.com

Contents

Foreword

One rainy afternoon at Chelsea art college the tutor called out... "draw each other". After a while, fellow students said "look, Tess keeps getting a likeness". I thought "isn't everyone else?"

This was the start of an obsession! My dear friend Murt sat happily for me for hours on end, no problem for him, despite the fact that it wasn't beside the river and there were no fish to be caught! During the following years I began receiving portrait commissions and twice had success at the National Portrait Gallery in the BP Portrait Award.

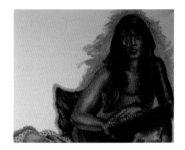

At the age of 29 I gained a place at Goldsmiths College in London to study Fine Art with Damien Hirst the year above me.

Within the first term, I was told by a tutor that portraiture was not art and was called a 'prostitute' by some students because I stayed in La Rochelle in France during the summer months and drew 20-minute portrait sketches, when actually this was great training and experience for me.

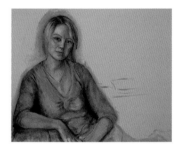

Having graduated from Goldsmiths in 1991, where I believe I was the only student to use paint in our degree show, I continued with my painting career and gave birth to my first daughter Emma.

I suddenly felt a great affinity with womankind and wondered how women with high profile jobs and careers managed both emotionally and physically with their work and children.

I had always been aware that, as a portrait artist, it was important to potential clients that the work I could show them was of people they could recognise. As I felt that portraits were often historically of male figures, I decided to embark on a series of portraits of women.

I soon realised that many women feel that they have to either make a decision to have children or focus on a career, or they feel simply too tied up with the constraints of work that the world of family and children are put to one side. So I wanted to include in this collection a spectrum of all women.

This project that I have undertaken has become the most fascinating and stimulating endeavour that I could ever have thought of. The figure 50 is significant in three ways...I am in my 50th year, there are 50 portraits in the collection and 50/50 is what we need in the workplace.

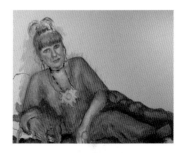

All the 50 wonderful women who have agreed be part of this series are simply fantastic. I thank them all for putting up with my incessant

chatter and I am indebted to their generosity of time and spirit. So many of my sitters have helped me along the way, such as...Caroline Hamilton sharing with me her expertise and writing a sponsorship proposal for me... Catherine Hughes and her husband Trevor giving me the opportunity to paint Richard Doll whose portrait now hangs in Green College Oxford... Kathy Lette for coming up with the idea of, and writing, these questions in this book. So many women recommended other women to sit for me and supported me by deciding to buy their finished portrait.

I could never have completed this mammoth task without the support and constant encouragement from my fantastic partner Mark and with the arrival of our two wonderful daughters Emma and Izzy, my zest, passion and drive for the project simply increased!

The world for women at work IS changing but the unbelievable fact that there is still unequal pay for women is unacceptable. I hope that this celebration of some of the country's top women will highlight this absurdity.

I am delighted to be able to support Breast Cancer Haven. I always knew that I wanted a breast cancer charity to benefit in some way but didn't know how. Not only will they gain funds via the auction prizes generously donated by many of the sitters but also they will benefit with each sale of this book!

I want to thank my many friends whose support in this venture has been invaluable. Their advice and enthusiasm at different stages throughout this journey was not just enormously helpful but most wonderfully generous as well.

Of course the crème de la crème happened when first direct gave the go ahead to sponsoring this exhibition on March 8th, which unbelievably is International Women's Day! They are a business that has been a delight to work with, I could never have hoped for such a lovely relationship. Who would ever have thought of a bank as sincere and friendly?! Their generosity, enthusiasm and support has been given with such warmth and humour, I am indebted to them.

Thank you to all who helped make this possible.

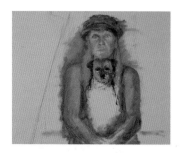

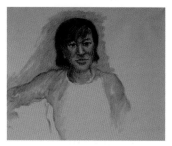

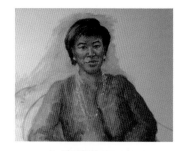

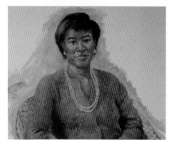

Sponsor

As the name suggests, first direct was the first UK bank to offer customers direct banking services so of course, we don't have branches. Consequently, we very rarely get to see our customers. Instead, we get to imagine what they might look like when we're talking to them on the phone So you won't be too surprised to discover how closely many of them turn out to resemble Brad Pitt or Angelina Jolie. Imagination really is a powerful thing.

But for all the fact that we deal direct on the phone and on-line, we're also very much a people business. And not just any people. We flatter ourselves that we employ really amazing people. But again sadly, our customers just don't get to see us, in the flesh as it were.

So, for a short time at least, we're delighted and incredibly proud to put a face, in fact 50 faces to first direct and to do so by helping to promote the extraordinary talent of Tess Barnes.

And talking about amazing people, I'm sure you'll agree that Tess very much fits the bill. Her portraiture really does stand out and eloquently reveals a little of the sitter's personal story.

We're doubly delighted that Breast Cancer Haven will benefit from the first direct 50 Women of Substance tour. As you'd expect, half of our customers and over 70% of our employees are women. It's sad but all too true that many of them will confront cancer in the course of their lives so any help that we can offer won't go unnoticed.

We hope you enjoy this beautiful book and that you get the opportunity to see the exhibition.

Thank you for your support.

first direct

Benefiting charity

Breast Cancer Haven offers a free programme of care to help patients and those supporting them during this difficult time. Havens are welcoming day centres staffed by a specialist team who provide support, information and complementary therapies before, during and after medical treatment.

Breast Cancer Haven
Effie Road
London SW6 1TB

T 020 7384 0099 *reception*
T 020 7384 0000 *fund raising and administration*
F 020 7384 0001

Breast Cancer Haven
37 St Owen Street
Hereford HR1 2JB

T 01432 361 061
F 01432 361 062

Capital Appeal Office
100 Wellington Street
Leeds LS1 4LT

T 0113 237 3017

History

In 1997 Sara Davenport sold her art gallery in order to start The Haven Trust (renamed Breast Cancer Haven in 2004). She was inspired to do this when her children's nanny was diagnosed with breast cancer and she could see the need to create somewhere like a Haven to help support her recovery. The first Haven opened in London in 2000 and the second in Hereford four years later. To date Breast Cancer Haven has helped over 4,000 Visitors, providing over 60,000 appointments to women and men affected by breast cancer.

Over the last ten years, Breast Cancer Haven has become recognised as one of the top four breast cancer charities in the UK, and is a member of the Breast Cancer Forum and the Complementary Cancer Care Charities Partnership.

Why is there a need for Breast Cancer Haven?

* 1 in 9 women in the UK develops breast cancer during their lifetime
* 25 women will die of breast cancer this week
* Over 44,000 new cases of breast cancer are diagnosed every year
* Men can get breast cancer too

The Future

Breast Cancer Haven intends to open a network of Havens across the UK until such time as a Haven is accessible from anywhere in the country. We aim to offer our services in areas of greatest need and will expand as quickly as resources allow. Five more Havens are planned over the next fifteen years, the locations of which will be established by considering a combination of incidence rates and the availability of local support and funding.

Plans for a third Haven are well underway and a £2,200,000 Capital Appeal has been launched to create a Haven in the heart of Leeds.

Credits

Winsor & Newton

Winsor & Newton has always been core to the world of art materials. It is as true now as it was when our company was founded in 1832 and we take our relationship with the artist very seriously. Our founders, Henry Newton and William Winsor were involved with the leading artists of their time such as JMW Turner. To this day, we strive to keep up with the latest developments in the art world and take an active interest in what artists say.

It was therefore a privilege to be asked by Tess Barnes to be involved in this exhibition particularly because it brings together a selection of her fantastic portraits whilst at the same time raising awareness for the charity, Breast Cancer Haven.

The World's Finest Artists' Materials

Michael Harding handmade artists oil colours

My paints are made by hand, using techniques which date back to the days of the Old Masters. There is a very simple reason for this painstaking process. As an artist and painter I wanted to create colours that were true and vibrant, and paint which was beautiful and durable.

The greater the pigment content of a paint the greater the resistance it has to fading. Nearly all manufacturers use various fillers to extend the volume of the oil paint. It may increase profits but it compromises on quality. I totally refuse to do this. Why make something exceptional and then dilute it?

Michael Harding

Acknowledgements

My special thanks go to...
first direct...for sponsoring me.
All the women who sat for their portraits.
Annabel Elton...who believed in this project from the start.
Wendy Smithers...from the 'Hub' for her expertise and advice.
Sue Armstrong...for her marketing skills.
Sara Norman...for collating the biographies.

Annie Fish...for the logo and the rest!
Robert Pritchard...for his editorial skills.
Sabine Durant...for her advice–and I haven't even met her yet!
Kathy Lette...for coming up with the questions in this book.
Madge Swindells...for her contacts.
Rick Fawcett...for a superb job putting this book together.
Möet Hennessy UK Ltd.

Sitters' comments

Valerie Amos
Tess Barnes is to be congratulated for pursuing her vision of an exhibition celebrating women's achievement. The project has gone from strength to strength. Tess Barnes's portraits are unique in that they reflect not only the person but the important elements in their lives. I wish her every success.

Shami Chakrabarti
Tess Barnes is a remarkable artist and woman. Sitting for her as part of this amazing collection of great women was both pleasure and privilege. Who needs shrinks or executive coaches when you can have Tess with her great talents for observation and empathy?

Kay Davies
Sitting for a vibrant artist was a completely different experience from what I had expected. Tess is a spontaneous warm personality who loves to exchange ideas about what motivates people in what they do. We had many conversations ranging from education in science (which affects both our families) to the impact of genetics in society. The sessions were fun and stimulating and I did not have to keep completely still!

Sophie Grigson
I love the way Tess captures the warmth and intelligence of her subjects, finding their humanity when so many others may see only the successful slightly scary exterior. Her work has a playfulness and insight that brings her portraits to life.

Caroline Hamilton
Tess is brilliant. Sitting for her was absolute pleasure from start to finish!

Catherine Hughes
Tess herself is vivid, direct, colourful—literally, from hair to foot—and deceptively calm and disciplined. One of her many gifts is the ability to provoke a response in others, of shared curiosity and pleasure. Her portraits are true dialogues, unmistakably from her brush, but seeking, not manipulating, the identity of the subject. Her personality is as creative as her skill in the interest and communication in her work.

Jenni Murray
I'm not the best subject for a painter. Fidgety, can't sit still, very self conscious about being looked at—so it should have been purgatory. But Tess is unfailingly cheery and chatty and managed to keep me occupied and entertained even though I wasn't allowed to read my book or my paper. She's also quick and very patient and never a word of complaint on those many occasions when the demands of a busy freelance career meant a cancellation at the last minute. And she's a great portrait painter too!

Elizabeth Neville
Having my portrait painted was a really enjoyable experience. Tess came to my house so it was like having a friend round to visit. She explained that she wanted to see me as a person and convey that in her painting. So we chatted and I found out quite a lot about her and she about me. I felt that she became a friend. I really like the way she puts personal things into the background of her paintings, to give a context to the subject. We have stayed in touch, and the whole process has been much more personal that I expected.

Gail Rebuck
I had never sat for a portrait before Tess Barnes approached me. It is strangely therapeutic to come home from work and have to sit still for an hour. I loved the way my daughters became engaged in the process and, in the end, Tess included them in the portrait, which we were all thrilled about. When Tess told me her aim was to paint enough women for a one woman show, I never thought she would do it—but she has—a testament to her enthusiasm and persuasive powers.

Stella Rimmington
Tess is not only a great portrait painter, she makes the sittings a really enjoyable experience. She likes to capture faces in motion, and she knows just how to keep her sitters involved. There is no danger of dropping off to sleep when Tess is painting your portrait.

Jacqueline Wilson
It was great fun to sit for Tess. You don't have to keep quiet and stay statue-still. We just laughed and chatted and enjoyed ourselves for a couple of hours here, a couple of hours there—and somehow the portrait got painted. I lived in a tiny house at the time, with huge piles of books and weird dolls hanging everywhere. The portrait is a very happy reminder of that time. I feel proud to be in the company of such interesting and talented women. I can't wait for the exhibition.

Baroness Valarie Amos OBE

FORMER LEADER OF THE HOUSE OF LORDS

Born in March 1954 in Guyana, Valerie Ann Amos was educated at Townley Grammar School for Girls before completing a degree in sociology at Warwick University in 1976, then a master's degree in cultural studies from Birmingham University in 1977. She did doctoral research at the University of East Anglia from 1978 until 2001. Valerie began her career in local government, working in various London boroughs from 1981 to 1989. She was chief executive of the Equal Opportunities Commission from 1989 to 1994 then from 1994 —1995 she ran Quality and Equality– a consultancy. In 1995 she became co-founder of Amos Fraser Bernard, a consultancy working in the areas of public service reform and equality issues, based in South Africa.

Valerie entered the House of Lords in 1997. From 1997 to 1998 she was Member of the European Union Sub Committee on Social Affairs, Education and Home Affairs. From 1998 to 2001 she was a Government Whip and Spokesperson on International Development, Social Security and Women's Issues. In 2001 she became the Foreign and Commonwealth Office Minister responsible for Britain's relations with Africa, the Commonwealth, Caribbean and Consular Services.

In 2003 she became the first black woman in a British Cabinet as Secretary of State for International Development. From 2003 until 2007 she was the Leader of the House of Lords.

Valerie has also been involved in a number of charitable and other organisations including being the chair of the board of governors of the Royal College of Nursing Institute, a director of Hampstead Theatre and Deputy chair of the Runnymede Trust.

Describe yourself in 5 words.
Supportive, committed, passionate, tough, fun.

What are your top 5 to 10 survival tips?
Be clear about what you want to achieve.
Work with people and nurture them.
Get feedback and remember to learn.
Its okay to be first.
Look for support, we all need it.
Remember to laugh and have fun.
Be flexible and take opportunities.

What is your favourite work of art?
Big Woman's Talk *by Sonia Boyce.*

What is your biggest obstacle that you have faced?
Other people's assumptions about what black women can do. Also my biggest asset.

What is your favourite word or words?
Do as in 'I can do that'.

Do you have a female role model?
The women in my family.

Who would you ask to a dinner party from history?
Yaa Asantewaa.

How did you get to where you are?
Hard work, support and lots of people believing in me.

Dame Jocelyn Barrow OBE DBE

FIRST BLACK WOMAN BBC GOVERNOR AND FORMER DEPUTY
CHAIR OF BROADCASTING STANDARDS COUNCIL

Dame Jocelyn has been active in voluntary and community organisations for over 35 years, involved in issues relating to race, gender, women and housing. In the 1960s her teaching career was a platform which enabled her to introduce multi-cultural education to address the needs of ethnic groups in the UK. She was the first black woman Governor of the BBC, and was Founder and Deputy Chair of the Broadcasting Standards Council. She was a founding member and General Secretary of CARD (Campaign Against Racial Discrimination) which developed into the Race Relations legislation of 1968.

Her Government appointments and voluntary public service include Governor of the Commonwealth Institute for eight years, Council member of Goldsmith's College, Trustee of the National Museums and Galleries of Merseyside, where she was instrumental in the establishment of the Trans-Atlantic Slavery Gallery and the Maritime Museum in Liverpool. She is also a Trustee of London's Horniman Museum and the Irene Taylor Trust providing music in prisons. She was Chair of the Inquiry for the Inns of Court Law School into the Education of Barristers, and Chair of the Inquiries into Secondary Education in Brent and in Newham. She has recently chaired (2003—2005) The Mayor of London's Commission on African and Asian Heritage.

In 1972, she was awarded an OBE for work in the field of education and community relations. In 1992, she was made a Dame of the British Empire (DBE) for her work in broadcasting and her contribution to the work of the European Union as a Member of the Social and Economic Committee, representing the UK in Brussels. Dame Jocelyn has received Honorary Doctorates from the University of East London in 1994, the University of Greenwich in 1996, the University of Middlesex in 1999 and the University of York in 2007.

Describe yourself in 5 words.
Helpful, fair-minded, intelligent and resolute.

What are your top 5 to 10 survival tips?
Believe in yourself.
Be open to criticism.
Treat everyone equally and with respect regardless of their status.
Make full use of every opportunity.
Always use your knowledge and skills to make a difference.
Be resolute, but fair in managing difficult situations.
Learn from your mistakes, and never let failure deter your progress.

What is your favourite work of art?
Water colours and sculptures painted by my three nieces and a nephew.

What is your biggest obstacle that you have faced?
Prejudice and discrimination.

What is your favourite word or words?
Equality, justice, respect, tolerance.

Do you have a female role model?
Not just one, but I take note and learn lessons from how powerful women have achieved their goals.

Who would you ask to a dinner party from history?
Olaudah Equiano.

How did you get to where you are?
Sheer determination and hard work and with the capacity to overcome obstacles.

Camila Batmanghelidjh

FOUNDER OF KID'S COMPANY

Camila is founder and director of Kids Company. Born in 1963 in Tehran to Iranian and Belgian parents she was sent to public school in Dorset. After the Iranian Revolution her sister committed suicide. Severely dyslexic, Camila used a tape recorder instead of pen and paper. She completed her degree in theatre and dramatic arts at Warwick University gaining First Class Honours. Then she did a Master's on the philosophy of counselling and psychotherapy, two years of child observation at the Tavistock Clinic in north London and art therapy at London's Goldsmiths College. For four years, she trained in psychotherapy and she also worked as a nanny.

Camila re-mortgaged to set up The Place to Be, offering psychotherapy and counselling to children in schools which helps over 20,000 children nationally a year. She set up registered charity Kids Company in 1996 to support children with difficulties resulting from trauma and neglect, using psychotherapy, counselling, education, arts, sports, hot meals and other practical interventions. In 2006, Kids Company helped over 11,000 clients through 33 London schools, a drop-in centre in Camberwell and a new, post-sixteen educational institute, the Urban Academy in Southwark. The charity has survived due to the support of charitable trusts and businesses yet Camila has twice re-mortgaged her home to raise funds.

Camila won the Social Entrepreneur of the Year Award 2005. She has written *Shattered Lives: Children Who Live with Courage and Dignity*, and other papers. She was nominated in The Good List 2006, of exceptional people and awarded the Woman of the year award for 2006 in recognition of her work with Kids Company. She has curated two major art exhibitions, one called *"Shrinking Childhoods"* at the Tate Modern in 2005 and *"Demons and Angels: Does it have to be this way?"* at Shoreditch Town Hall.

Describe yourself in 5 words.
Deliciously embracing life with humour.

What are your top 5 to 10 survival tips?
Good lipstick.
Moral courage.
Follow your gut instinct.
Truth is strength.
Die before you have false teeth.

What is your favourite work of art?
Artwork by children of Kids Company.

What is your biggest obstacle that you have faced?
Envy from "little" people.

What is your favourite word or words?
Compassion.

Do you have a female role model?
Russian babouska dolls.

Who would you ask to a dinner party from history?
Leonardo Da Vinci.

How did you get to where you are?
Definitely by accident.

Catherine Bishop

FOREIGN OFFICE DIPLOMAT, FORMER ROWER AND
SILVER MEDAL WINNER

Catherine is an Olympic medal-winning rower. She was born in 1971. She has a BA in Modern Languages (German and Russian) from Pembroke College, Cambridge where she started rowing, a Master's in International Politics from the University of Wales, Aberystwyth and a PhD in contemporary German literature from the University of Reading. Three times an Olympian, five times a World Championship finalist, she won her first GB vest at the 1995 World Championships and her first world medal at the 1998 World Championships when she won a silver medal in the Women's Coxless Pairs with pairs partner Dot Blackie.

Catherine took a year off from the end of 2001 and joined the Foreign Office Diplomatic Service, but returned to training a year later to renew her rowing partnership with Katherine Grainger. (The duo were 5th at the 2001 world championships). They were coxless pairs World Champions in 2003, and World Cup Champions in 2003 and 2004 medalling at all three international races which make up the World Cup both years, and went on to win a Silver Medal in the 2004 Athens Olympic Games. Catherine retired from rowing after Athens to concentrate on her career with the Foreign Office. After working on European issues when she first joined the Foreign Office, Catherine learnt Serbo-Croat (whilst training for the Athens Olympics) to take up a posting in the British Embassy in Sarajevo at the end of 2004, and is currently serving as Head of the Political Section of the British Consulate in Basra, Iraq.

Describe yourself in 5 words.
Always up for a challenge.

What are your top 5 to 10 survival tips?
Look for the positives.
Never underestimate what you are capable of or what others are capable of.
Hope for the best, prepare for the worst.
All things are possible.
Believe in yourself (the hardest one but most important one).

What is your favourite work of art?
Edvard Munch's 'The Scream'.

What is your biggest obstacle that you have faced?
Dealing with the bitter disappointment of failing to win a medal at two Olympics (Atlanta, Sydney), tackling the ensuing loss of form and total loss of self-belief to pick myself up, turn my performance levels around and put my neck on the line a third time in order to win an Olympic medal in Athens.

What is your favourite word or words?
No single word-anything that makes me smile or laugh. I love languages and hearing sounds in other languages that do not exist in our own.

Do you have a female role model?
Any woman who's forged a new path and gone against conventions–all in her own style.

Who would you ask to a dinner party from history?
A pharaoh from Ancient Egypt, an emperor from Ancient Rome and a ruler from Ancient Greece.

How did you get to where you are?
I often ask myself that question-One step at a time, I guess.

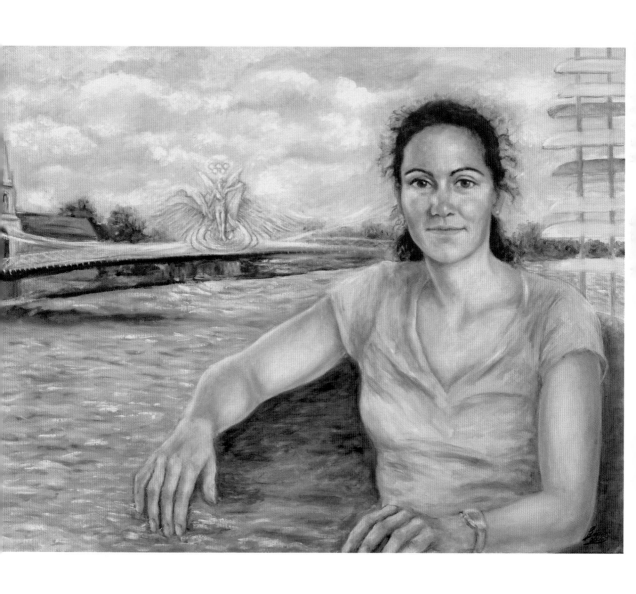

Rosie Boycott

JOURNALIST AND BROADCASTER

Rosie Boycott has had a highly distinguished career in journalism. She became the first woman editor of two national broadsheets, the Independent on Sunday and the Independent (1996—1998). Before that she spent four years as editor of men's magazine Esquire, where she pioneered the Esquire prize for non-fiction, almost doubled its circulation and won Editor of the year award in 1993 and 1994. Her appointment as editor of the Daily Express in 1998, by the Blairite Labour peer Lord Hollick, marked a dramatic about-turn in the formerly right-wing newspaper.

Rosie Boycott dropped out of Kent University in the Seventies to go to London to work on the underground press where she was one of the co-founders and editors of the feminist magazine, Spare Rib and later the publishing house Virago Press, publisher of women's writing. She is also an author in her own right, publishing her autobiography, *A Nice Girl Like Me* in 1984, about her battle with alcoholism. Rosie is a regular participant on BBC Two's *Newsnight Review*, she presents Radio Four's *A Good Read* and often contributes to TV and radio. Last year she made one of the BBC's *Great Britons* films on Princess Diana. Rosie Boycott is one of the UK's leading journalists and broadcasters, and has frequently been in the vanguard of significant social and political movements. While editor of the *Independent on Sunday* she campaigned to decriminalise cannabis. She has chaired the committees for both the Orange Prize and the Samuel Johnson Prize. Her book Our Farm: *A Year in the Life of a Smallholding*, (May 2007) follows the ups and downs of her attempt to set-up a smallholding that is self-sufficient within eighteen months.

Describe yourself in 5 words.
Stubborn, persistent.

What are your top 5 to 10 survival tips?
Don't give up.
Get fully engaged in whatever you are doing right now.
Don't be afraid to show you care passionately about an issue (ie don't be too cool...).
Get a good night's sleep.
Find a good partner.
Don't put off having children till its too late.
Dogs really are worth it.
Keep fit–all the cliches are true!
Have good friends and make time for them, they never let you down.

What is your favourite work of art?
Turner's watercolours of the English landscape.

What is your biggest obstacle that you have faced?
Alcoholism.

What is your favourite word or words?
Sunlight.

Do you have a female role model?
Polly Toynbee, Wangari Maathai.

Who would you ask to a dinner party from history?
Anne Hathaway, Henry 8ths wives, Mrs Einstein, Mrs Darwin, Mrs Gallileo...in other words, I'd like to meet the wives of the men who shaped our world and discover the part they played in their success.

How did you get to where you are?
By always saying yes to the opportunities that arose and never believing that anything was impossible.

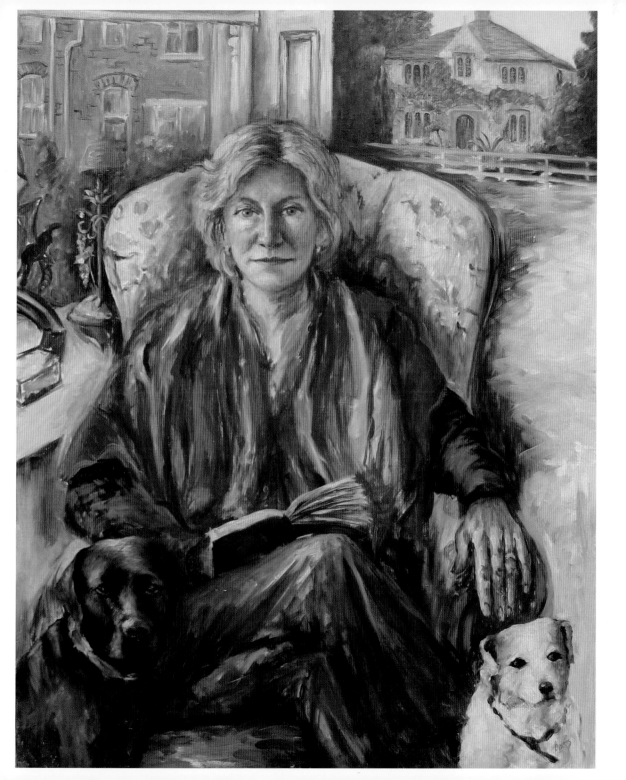

Deborah Bull CBE

CREATIVE DIRECTOR, ROH2, ROYAL OPERA HOUSE

Deborah Bull danced with The Royal Ballet for twenty years earning an Olivier nomination for her role in William Forsythe's *'Steptext'*. She left in 2001 to become Creative Director of the Royal Opera House, where she is responsible for a wide range of activity and initiatives, including an alternative performance programme, opera and dance development initiatives, commercial activity, big screen live relays from the main stage, an *'On the Road'* programme and daytime activities. In addition, she oversees the ROH's extensive archives. She regularly presents dance for the BBC and was seen most recently in the major BBC2 series, *'The Dancer's Body'* and in Artsworld's 10-part *'High Definition'* series, *'Saved for the Nation'*. She has written and presented several programmes for the BBC, including, for Radio 4, two series on law. For Christmas 1998, she presented BBC2's first ever *'Dance Night'* with the comedian Alexei Sayle. Her four-part BBC2 series, *'Travels with my Tutu'*, won record audiences for dance in December 2000 and *'The Dancer's Body'*, screened in September 2002, made dance accessible to a wider public. She has published three books– *'The Vitality Plan'*, *'Dancing Away'* and *'The Faber Guide to Classical Ballets'*.

With her active interest in the health of young dancers, she taught nutrition to the Royal Ballet School. She sits on the artistic advisory board of the annual Prix de Lausanne in Switzerland. She served on the Arts Council for England for six years and as a Governor of the BBC from 2003 to 2006. Deborah has received Honorary Doctorates from Derby and Sheffield Universities and the Open University and was named a Commander of the Order of the British Empire in the Queen's Birthday Honours List of 1999. She is a Patron of the National Osteoporosis Society, Foundation for Community Dance and Escape Artists and an Honorary Vice President of Arts and Business and Voices of British Ballet.

Describe yourself in 5 words.
Resistant to categorization.

What are your top 5 to 10 survival tips?
Listen to your stomach-or whichever part of your body has the most honest response to any situation.
Put yourself in other people's shoes before you judge their actions.
When things get tough, hold on to what you believe and know that nothing lasts forever.
Get enough sleep.
Drink plenty of water.
Invest in communication.
Define your personal boundaries, and be wary of people who don't respect them.
Wear sunscreen.

What is your favourite work of art?
William Forsythe's Steptext.

What is your biggest obstacle that you have faced?
The very things which have stood me in good stead; the idiosyncrasies of my personality.

What is your favourite word or words?
Integrity, rigour, love, honesty, breakfast.

Do you have a female role model?
No, but there are many women I admire.

Who would you ask to a dinner party from history?
Nelson Mandela.

How did you get to where you are?
By saying yes to things that seemed either interesting, worthwhile or fun.

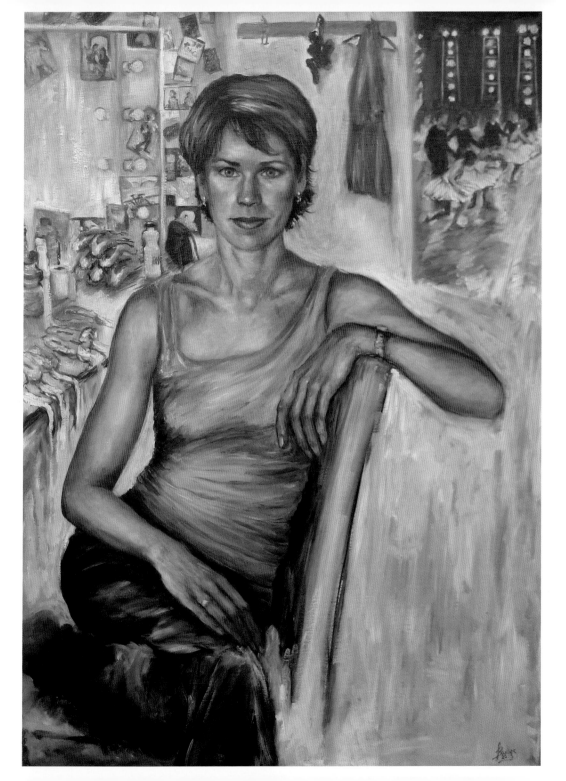

Shami Chakrabarti CBE
DIRECTOR OF LIBERTY, HUMAN RIGHTS

Shami has been Director of Liberty (The National Council for Civil Liberties) since September 2003. She was made a CBE in 2007. After graduating from the London School of Economics, Shami was called to the Bar in 1994 and worked as a lawyer in the Home Office from 1996 until 2001 for Governments of both persuasions. Shami first joined Liberty as In-House Counsel on 10 September 2001. She became heavily involved in its engagement with the 'War on Terror' and with the defence and promotion of human rights values in Parliament, the Courts and wider society.

Since becoming Liberty's Director she has written, spoken and broadcast widely on the importance of the post WWII human rights framework as an essential component of democratic society. She is a Governor of the London School of Economics and the British Film Institute, a Visiting Fellow of Nuffield College, Oxford and a Master of the Bench of Middle Temple. She is a frequent and lively contributor to debates on human rights and civil liberties on the BBC and for *The Independent* newspaper. In 2006 she was short listed for Channel 4's Political Awards for 'The Most Inspiring Political Figure' and this year was short listed for ITV's *Greatest Britons* poll. Shami was born in London in 1969 and still lives in London with her husband and young son.

Describe yourself in 5 words.
Mother, wife, daughter, rights campaigner.

What are your top 5 to 10 survival tips?
The light returns in the morning.
Being happy helps.
Its nice to be nice.
You are any ones equal and no ones superior.
This too will pass so make the most of it.

What is your favourite work of art?
Anything by my son.

What is your biggest obstacle that you have faced?
Self doubt.

What is your favourite word or words?
Liberty.

Do you have a female role model?
Too many to count let alone name, but certainly my mother.

Who would you ask to a dinner party from history?
Eleanor Roosevelt.

How did you get to where you are?
By love, luck, accident and application.

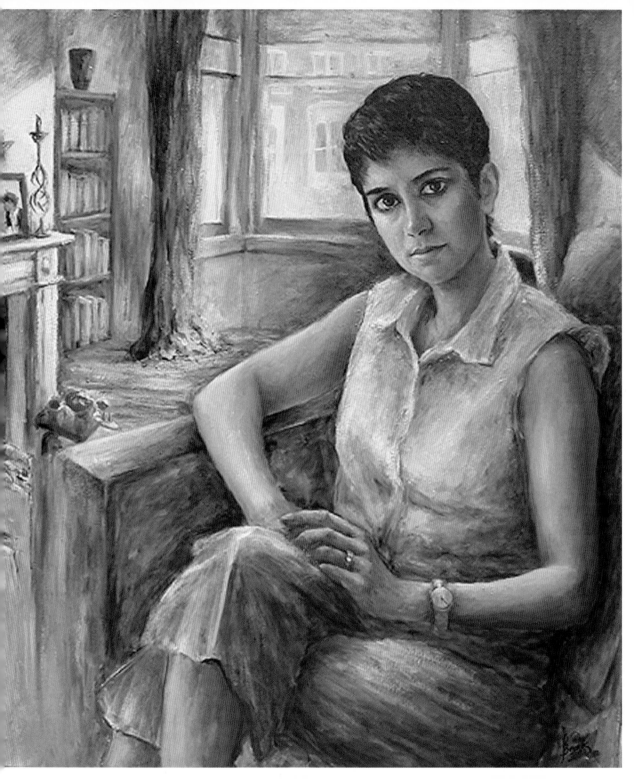

Baroness Lynda Chalker

PAST CHAIRMAN OF LSHTM. CHAIRMAN OF
MEDICINES FOR MALARIA VENTURE

Lynda is Chairman of Africa Matters Limited, a pan African group of advisers seeking to take investment into African businesses and keep them viable. With her considerable experience of African cultures and relationships, and of the numerous business and development issues crucial to Africa, she supports the work of the company, providing leadership and political insights which help make Africa Matters Limited unique.

Lynda has been a member of the Lower and Upper Houses of the UK Parliament for over thirty years. Between 1986 and 1997 she was Minister of State at the Foreign & Commonwealth Office, holding responsibility for Africa and the Commonwealth and for Overseas Development. She was made a Life Peer in 1992. She was the first woman to be appointed first as an Advisory, and then as a non-executive, director of Unilever. She is also a non-executive director of Group Five (Pty), a member of the international advisory boards of Lafarge et Cie, MerchantBridge Ltd. and Merchant International Group and an adviser to the World Bank.

Lynda is Chairman of the Medicines for Malaria Venture (MMV), an Executive Trustee of the Global Leadership Foundation (GLF) and Trustee of the Investment Climate Facility for Africa (ICF) and of the Nelson Mandela Legacy Trust (NMLT), as well as being a patron of a number of charities. She is also co-ordinator of the Honorary International Investment Council of President Yar 'Adua of Nigeria and a member of similar bodies in Kenya, Uganda and Tanzania.

Describe yourself in 5 words.
Determined, resilient, caring, informed, organised.

What are your top 5 to 10 survival tips?
Focus on the necessary, be as you would be done by, plan ahead, be friendly but firm, and be thorough.

What is your favourite work of art?
Degas' Ballerina.

What is your biggest obstacle that you have faced?
Restarting an independent life after divorce.

What is your favourite word or words?
Every cloud has a silver lining.

Do you have a female role model?
Helen Suzman.

Who would you ask to a dinner party from history?
Florence Nightingale.

How did you get to where you are?
Hard work.

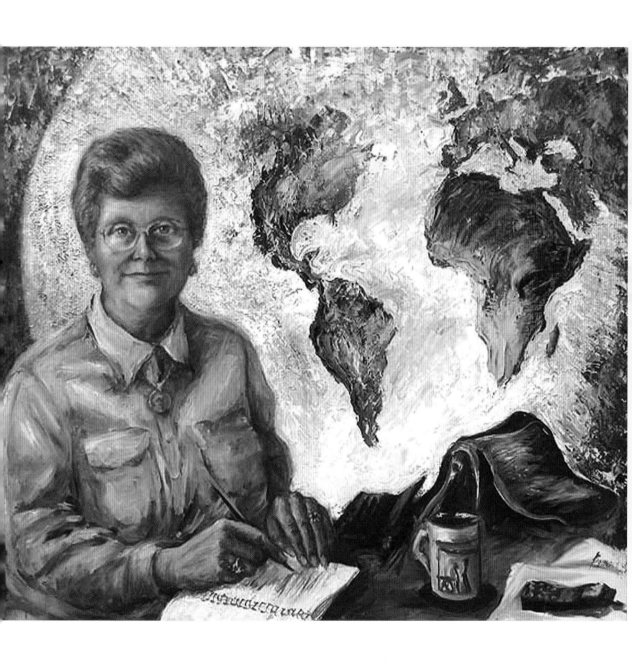

Dr June Crown CBE, FRCP, FFPH

PRESIDENT OF THE FACULTY OF PUBLIC HEALTH
MEDICINE 1995—1998

Dr June Crown has served as Area Medical Officer in Brent and Harrow, Director of Public Health in Bloomsbury, London and Director of the South East Institute of Public Health. She was President of the United Kingdom Faculty of Public Health Medicine (of the Royal College of Physicians) from 1995 to 1998. She has frequently acted as a special advisor to the World Health Organisation and overseas Governments and has undertaken work related to health services reform in central and eastern Europe, most recently in Russia.

She chaired the 1989 Department of Health review on nurse prescribing which led to the extension of prescribing rights to District Nurses and Health Visitors, and subsequently the Review (March 1999) of the Prescribing, Supply and Administration of Medicines which has led to further extensions of prescribing rights to other health professionals in all settings.

In 'retirement', she has been Chairman of Age Concern England from 1998 to 2002 and is now its Vice-President. She was appointed a Trustee of Help the Aged in 2003. She chairs the Inquiry into the Mental Health and Well-being of Older People which is being undertaken on behalf of the Mental Health Foundation and Age Concern England.

Dr June Crown was appointed Vice-Chairman of the Governors of Brighton University (the University Council) in 2002 and represents the University on the Brighton and Sussex Medical School Joint Board. She is also currently President of Medact.

Describe yourself in 5 words.
Lucky, loyal, loving, laughing and lazy.

What are your top 5 to 10 survival tips?
Be clear about your values and priorities and stick to them when put to the test.
Be ready to grasp opportunities–"fortune favours the prepared mind".
Have a good team and make sure they feel valued and appreciated.
There's more to life than work - families, culture, travel and outside interests are important too.
Be generous with your time and advice.

What is your favourite work of art?
Public art–Michelangelo's Pieta, the most human and moving sculpture I have ever seen.

What is your biggest obstacle that you have faced?
The 24 hour day.

What is your favourite word or words?
I love you, Grandma.

Do you have a female role model?
Not quite a role model, but I was greatly influenced by my headmistress at Pate's Grammar School, Dame Margaret Miles.
She encouraged everyone to achieve their potential and was particularly helpful in supporting girls from families like mine, with no tradition of higher education. I doubt I would have gone to Cambridge were it not for her.

Who would you ask to a dinner party from history?
Pushkin and Mary Seacole–probably on different occasions!

How did you get to where you are?
Thanks to an excellent education, and by moving into public health in the 1970s, working with exciting colleagues and being passionate about improving the health and well-being of the population.

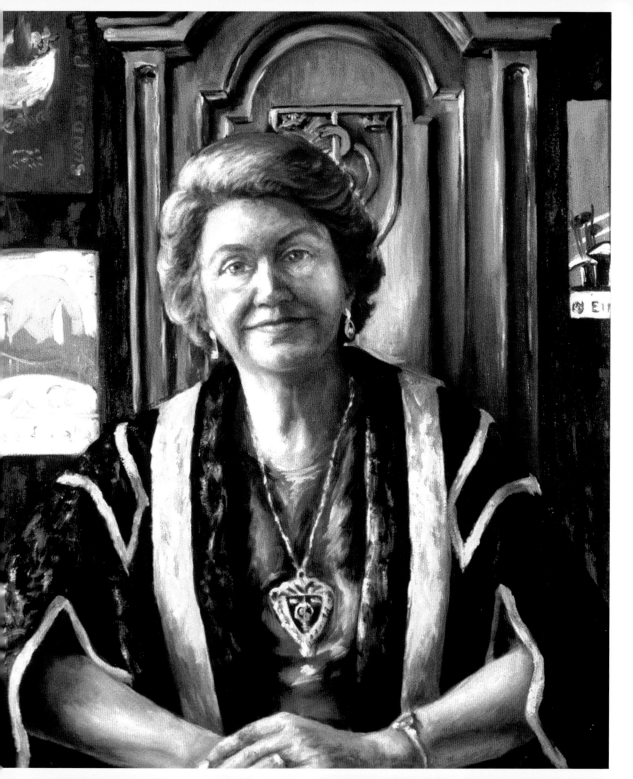

Dame Kay E Davies CBE, DBE, FMedSci, FRS

GENTETICIST

K ay Davies was an undergraduate at Somerville College
and a Junior Research Fellow at Wolfson College, Oxford.
She was elected as Dr Lee's Professor of Anatomy at the
University of Oxford in 1998. Her research interests lie in the
molecular analysis of human genetic disease, particularly the
genetic basis of neuromuscular and neurological disorders. She first
became interested in ,uscular dystrophy more than 20 years ago
and much of her research group is dedicated to finding effective
treatments for Duchenne Muscular Dystrophy (DMD) and Spinal
Muscular Atrophy. In 1999, she set up the MRC Functional
Genetics Unit aimed at exploiting genome information for the
analysis of the function of genes in the nervous system.

She is currently its Director. In 2000, she co-founded the
Oxford Centre of Gene Function with Professors Ashcroft
(Physiology) and Donnelly (Statistics) to bring together genetics,
physiology and bioinformatics in a new multidisciplinary building
which was completed in 2003. She is Co-director of this new
initiative. She has an active interest in the ethical implications
of her research and in the public understanding of science. She is
a founding fellow of the Academy of Medical Sciences and was
elected a Fellow of the Royal Society in 2003.

Describe yourself in 5 words.
A passionate scientist.

What are your top 5 to 10 survival tips?
Continued optimism.
Love of the job.
Being organised but not too bossy.
Never panicking however hard it gets.
Keeping a good sense of humour.
Always having something to rescue you; music
or friendship, preferably both!
Being patient with others who may not be
able to share your work ethic but do share your
values.

What is your favourite work of art?
Anything by Picasso.

What is your biggest obstacle that you have faced?
Talking to patients with Duchenne Muscular
Dystrophy who are terminally ill but may still
have at least five years to live. Sharing their
hopes and admiring their courage.

What is your favourite word or words?
"Biology is truly a land of unlimited
possibilities" Freud Beyond the Pleasure
Principle *(1920).*

Do you have a female role model?
The late Anne McClaren.

Who would you ask to a dinner party from history?
Isaac Newton.

How did you get to where you are?
Being quietly determined and committed to
curing muscular dystrophy. Being fortunate
enough to work with many talented people.

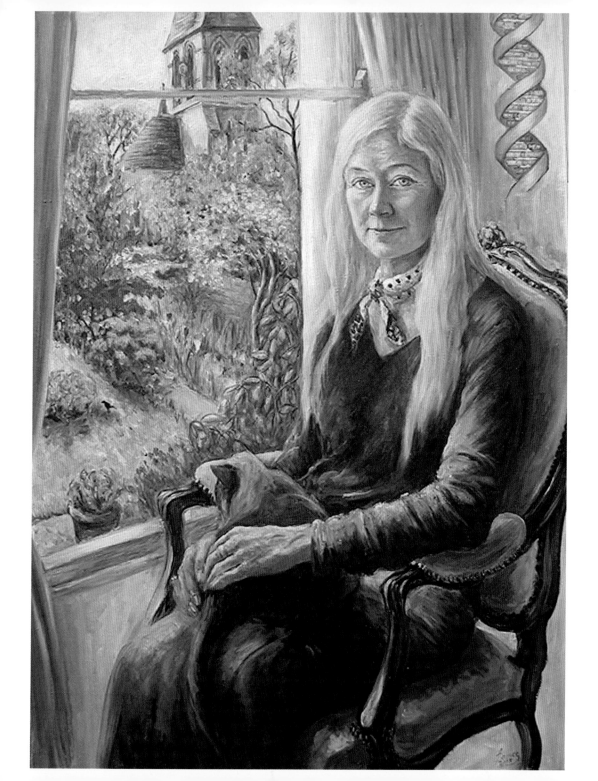

Baroness Brenda Dean PC

CHAIRMAN COVENT GARDEN MARKET AUTHORITY.
FORMERLY FIRST FEMALE LEADER OF A MAJOR TRADE UNION
IN THE UK

Brenda was born in Salford, Lancashire in 1943 in the middle of an air raid. She left school at sixteen and went to work as a secretary in a printing firm. She soon became a junior official and swiftly rose through the ranks, becoming President of the Society of Graphical and Allied Trades (SOGAT) in 1983 and General Secretary in 1985, the first elected female leader of a major trade union. She documented her time at SOGAT in her autobiography *Hot Mettle*, in which she tells of the battle against Rupert Murdoch and how she met Murdoch personally for several secret last-ditch attempts to resolve the clash. Brenda lost the battle, but went on to become a working peer, and still campaigns tirelessly to improve the lives of employees in Britain, as well as occupying an active – if behind the scenes – role in government. In 1993 she entered the House of Lords as life peer Baroness Dean of Thornton-le-Fylde and became a Privy Councillor in 1998. She has been a member of numerous public bodies and committees, and served as Vice-Chair of the University College London Hospitals NHS Trust from 1994 until 1998, when she was appointed to Chair the Housing Corporation.

Describe yourself in 5 words.
Trade Unionist, independent, impatient, loyal, lover of creature comforts.

What are your top 5 to 10 survival tips?
Remember where you came from and don't pretend to be what you are not.
Value family and home life.
Spend time on your appearance.
Always make sure you read your papers.
Build alliances – and maintain them.
When opportunities arrive seize them.
Have confidence in yourself and your judgement.
Keep faith with the sisterhood.

What is your favourite work of art?
Memorial in Whitehall to commemorate the role of women during World War II.

What is your biggest obstacle that you have faced?
Seeking a resolution to the 1986 year long dispute between SOGAT, and News International.

What is your favourite word or words?
Life, freedom, love.

Do you have a female role model?
Barbara Castle, Annie Besant, Sylvia Pankhurst and Ellen Wilkinson would have to figure in any list.

Who would you ask to a dinner party from history?
Do you have a table big enough? Here goes with some: Queen Elizabeth I, President Saddat, Isambard Brunel, Octavia Hill, Mary Seacole, Elizabeth Johnson, President Franklin Roosevelt, Lord Horatio Nelson, Mrs. Beaton, Sylvia Pankhurst.

How did you get to where you are?
Why not? factor.
Fair election process for union jobs early in my career.
Luck - and being in the right place at the right time.

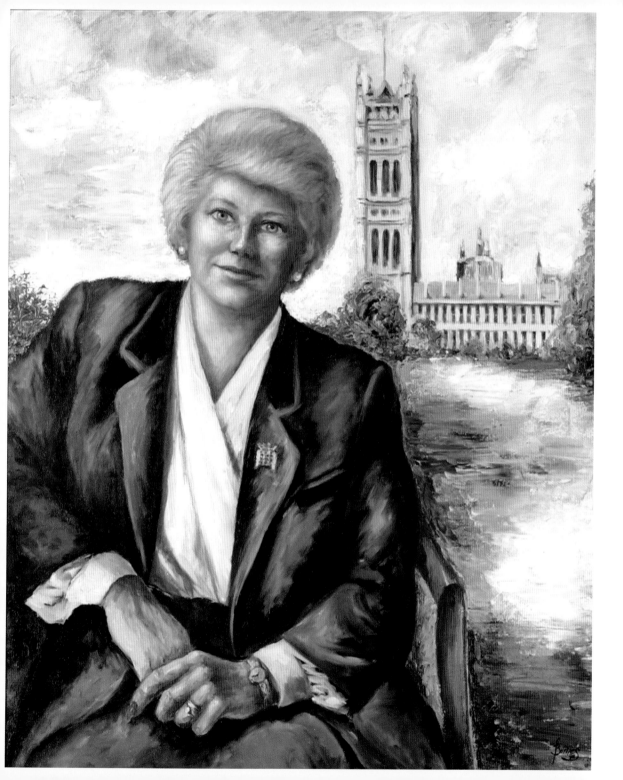

Brigadier Jean Dowson MBA, BSc, FCIPD, FCMI

In 2006 the Most Senior Serving Female Officer
in all Three Armed Services

Brigadier Jean Dowson was born in 1955 and educated at St Hilds College, Durham. After a period teaching music, she was commissioned into the Women's Royal Army Corps in 1977, transferring to the Adjutant General's Corps (AGC) on its formation in 1992. She has served with Royal Signals and the Intelligence Corps as well as on loan service with the Sultan of Brunei's Armed Forces. She attended the Army Staff College in 1988 followed by a tour in Whitehall within the Adjutant General's Department (the Army's Principal Personnel Officer). She commanded a Signal Squadron in Catterick and was the first female to command a University Officers Training Corps (Birmingham) in 1994. She became the first female commandant when she was promoted to Colonel at the age of 40 and assumed command of the AGC Training Group, part of the Army Training and Recruiting Agency, where she was responsible for military police training, language training, clerical and financial training, as well as leadership and development training for young soldiers and officers within her Corps. Jean attended the Royal College of Defence Studies in 1998, after which she assumed responsibility for the Army's strategic manpower planning and terms of service for officers and soldiers.

Promoted Brigadier in 2001, she became the HR Director in the Defence Logistics Organisation until 2005 when she moved back to Whitehall into another tri-service appointment where, as Director of Service Personnel Policy, she was responsible for compensation and benefit policy for 200,000 personnel. In 2006, she left the Army as the most senior serving female officer in all three Armed services and is now working as a Leadership Coach and NLP Consultant. A keen squash player, an enthusiastic skier, she enjoys classical music, is a member of the Parliament Choir and enjoys hill walking and travelling. She is now the Honorary Colonel of Birmingham University Officers Training Corps.

Describe yourself in 5 words.
Hardworking, dedicated, loyal, firm but fair, fun!

What are your top 5 to 10 survival tips?
You are never too senior to ask for help!
Have something worthwhile to say. Remember that small actions on your part stay with your subordinates for ever.
Don't forget to manage upwards.
Take praise with grace and feedback with thanks.
Show consideration for other people's viewpoints.
Always carry a spare pair!
Allow yourself some "me time".
Don't take everything personally.
Never let the sun go down on an argument.

What is your favourite work of art?
Turner Durham Cathedral.

What is your biggest obstacle that you have faced?
Recognizing that what makes me different also makes me me.

What is your favourite word or words?
I will lift up mine eyes unto the hills, from whence cometh my help (Psalm 121).

Do you have a female role model?
Not one but many, male and female, and I have tried to learn from and emulate what they do well and avoid what didn't go so well.

Who would you ask to a dinner party from history?
Wellington, Mo Mowlam, Leonardo Da Vinci, The Queen Mother, Ernest Shackleton, Marie Curie, Mahatma Gandhi, Florence Nightingale, JS Bach, Oliver Cromwell, My mum!

How did you get to where you are?
Through a belief in myself to know what was right, the ability and courage to do what was right and the encouragement and love of some amazing family and friends to guide, support and advise me, come what may.

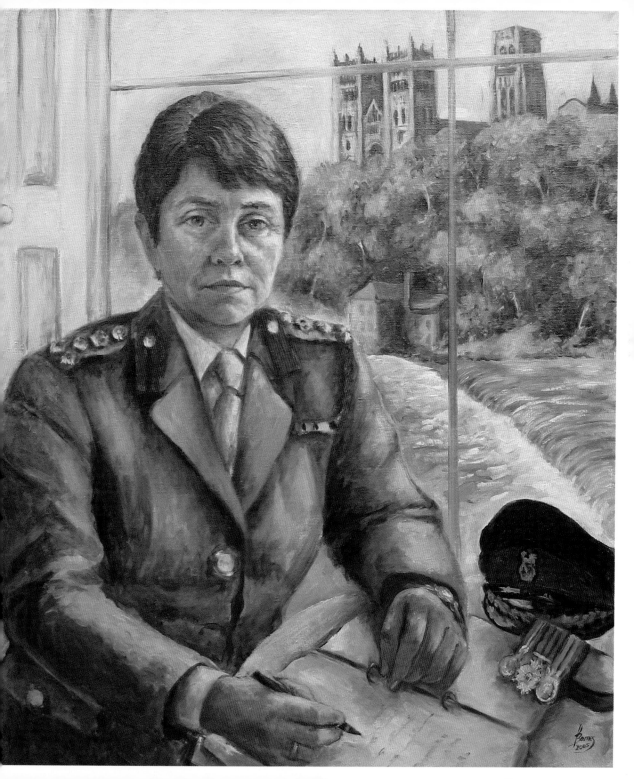

Rachael Heyhoe-Flint OBE, MBE

FORMER CAPTAIN OF THE ENGLAND WOMEN'S CRICKET TEAM

Rachael Heyhoe-Flint epitomised women's cricket in England for more than a generation, bringing it a respectability and a higher profile than it had enjoyed previously. Born in Wolverhampton in 1939, she rose to the pinnacle of English cricket and remains in many people's minds the most recognisable women's cricketer. After she retired she has continued to promote the sport through her strong media presence and personality. As a batsman, she was one of the best, capable of cavalier aggression or determined defence. She took over the England captaincy in 1966 and remained unbeaten in six series. Her crowning glory was leading England to victory in the 1973 World Cup, not least because she had been instrumental in getting the tournament off the ground, thanks to the generous patronage of Sir Jack Hayward, two years before the men's World Cup. In 1976, aged 37, she was the captain of England's first women's team ever to play at Lord's, the same year she scored a match saving and series saving 179 at the Oval in the final Test against Australia. In 1972 she was awarded an MBE for her services to cricket. She was named an Honorary Life Member of the MCC after leading a 9-year campaign to be admitted. (The MCC has its headquarters at Lords' Cricket Ground and is the custodian of the Laws of Cricket). In 2004 she became the first ever woman to be elected on to the main Committee of the MCC. An accomplished after-dinner speaker, Rachael qualified as a journalist and public relations executive having originally trained as a teacher of physical education; she is Director of PR at Wolverhampton Wanderers Football Club (which she has supported since the 1950s). She also played hockey for England as a goalkeeper and played county squash and golf for Staffordshire. Rachael became President of the Lady Taverners in 2000–the fund raising arm of the prestigious Lord's Taverners who jointly fund inner city cricket projects, sports wheelchairs, specially adapted mini buses – in order to give youngsters with special needs a sporting chance.

Describe yourself in 5 words.
Energetic, stubborn, determined, amusing, kind hearted.

What are your top 5 to 10 survival tips?
Eat healthily, golf, exercise, work, brandy night cap, positive thinking, health tablets, spend as little time as possible in the kitchen, be kind to all human life!

What is your favourite work of art?
Constable's Hay Wain *(how corny!).*

What is your biggest obstacle that you have faced?
To gain respect and recognition of women's cricket throughout the world and to enable women to become members of the MCC.

What is your favourite word or words?
British, happiness, well done!

Do you have a female role model?
Margaret Thatcher and The Queen.

Who would you ask to a dinner party from history?
Winston Churchill, Emily Pankhurst, Marie Antoinette, CB Fry, Amy Johnson, Jesse Owens.

How did you get to where you are?
All that has happened has been almost by accident, but I suppose to be accepted in the world of cricket occurred because of my determination to be accepted and sheer bloody mindedness and persistence.

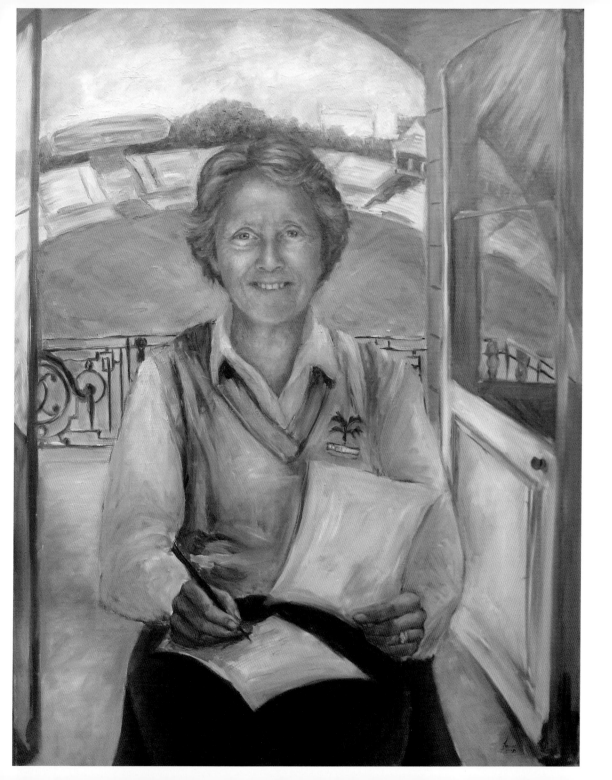

Angela Flowers

ANGELA FLOWERS GALLERY

Angela was born in Croydon, Surrey in 1932; she attended Westonbirt School and Wychwood School, Oxford. In 1949 she spent a year in Paris studying art and music in Paris before returning to London to attend the Webber Douglas School of Singing and Dramatic Art from 1950 to 1952 where she was awarded a diploma. In 1954 she visited St. Ives and met Ben Nicholson, Barbara Hepworth, Roger Hilton, Terry Frost and other artists. During this time Angela had various jobs in advertising, film and photography. In 1969 she started work at London's Institute of Contemporary Arts and on February 10, 1970 she opened the Angela Flowers Gallery on central London's Lisle Street, above the Artists International Association. In 1984 she opened Angela Flowers (Ireland) Inc in Rosscarbery Co Cork. Then in September 1988 she launched Flowers East, a 4,500 sq foot space in Richmond Road, London E8, deciding in 1989 to concentrate all the gallery operations from these premises. In 1991 an additional 18,000 sq foot was opened in Richmond Road. In 1994 Angela became a Senior Fellow at London's Royal Collage of Art and was awarded an Honorary Doctorate from the University of East London in 1999. In 2002, Flowers East moved premises to Kingsland road, London E2. Angela has three sons and a daughter with photographer Adrian Flowers (they were married in 1952 and divorced 1973) and a daughter Rachel (born 1973) with Robert Heller who she married in 2003.

Describe yourself in 5 words.
Bully, bossy, generous, kind, musical.

What are your top 5 to 10 survival tips?
Music, art, laughing, gin & tonic.

What is your favourite work of art?
Rembrandt self-portrait in Kenwood.

What is your biggest obstacle that you have faced?
Divorce.

What is your favourite word or words?
Shocking, darling.

Do you have a female role model?
Ingrid Bergman.

Who would you ask to a dinner party from history?
JS Bach, Orson Welles, WB Yeats, Duke Ellington, Van Gogh, Rembrandt, Dorothy Parker.

How did you get to where you are?
Love.

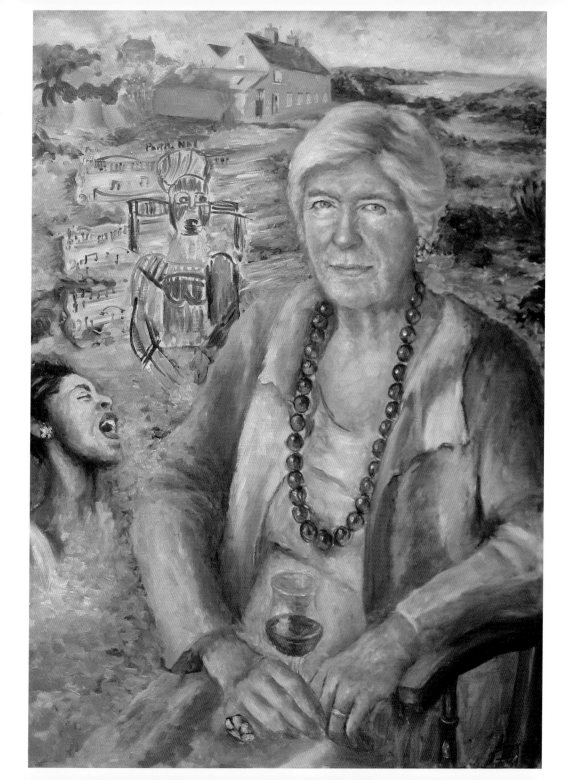

39

Lynne Franks

AUTHOR AND BUSINESS WOMAN

Author, entrepreneur and lifestyle guru Lynne Franks has a communication reach that stretches across the world. As a business woman and founder of the SEED empowerment programmes for women, she regular speaks in the media on social change, consumer patterns, corporate responsibility and women in business.

After leaving school at sixteen, she became a secretary, then set up Lynne Franks PR, at the age of twenty-one, one of the world's best-known agencies, guiding multi-national businesses and non-profit organisations. After twenty years, Lynne left her agency in 1992 and became an international spokesperson and facilitator on world changes today and in the future.

In 1994, she chaired the UK's first women's radio station, presenting her show, *Frankly Speaking*. Prior to attending the UN Women's Conference in Beijing in 1995, Lynne created the major UK event, *What Women Want*, focusing on the changing position of women in society. She has authored four books, including *The SEED Handbook: The Feminine Way to Create Business*, published in 2000, which struck a chord with women around the world. SEED provides internationally recognised women's enterprise and leadership training programmes, as well as a global women's network. Supported by the British Government's Department of Trade and Industry's Strategic Platform for Women and Enterprise, SEED's facilitators have taught the programme across the UK.

In 2007, The Tribal Group launched their SEED Women into Enterprise Programme in partnership with Lynne as an educational blended learning tool, delivered through enterprise agencies, FE's, women's prisons and women's community initiatives. Lynne also initiated SEED Coaches Training and SEED Community Peer Circles in 2007. She is a founder judge and spokesperson for the Government's Enterprising Britain Awards as well as a judge on international enterprise and environmental awards. She advises both private and public sectors as well as developing communication strategies for NGO's and community initiatives.

Describe yourself in 5 words.
Passionate, creative, productive, compassionate, spiritual.

What are your top 5 to 10 survival tips?
Live your truth.
Recognise the journey is the destination.
Create the life of your dreams.
Work towards your potential in every area of your life.
See your beauty.

What is your favourite work of art?
So much Hockney, Picasso ceramics, all the artists of Deià where I live in Mallorca, especially my good friend Frances Baxter Graves.

What is your biggest obstacle that you have faced?
Loving myself.

What is your favourite word or words?
Om Shanti I am the peaceful one.

Do you have a female role model?
Dadi Janki, the 92-year-old leader of the Brahma Kumaris the only women-led spiritual organisation in the world.

Who would you ask to a dinner party from history?
Ghandi and Mrs Ghandi, Ella Bhat the founder of SEWA, Wangari Mathai, Dadi Janki, Nelson Mandela, Ellen Johnson-Sirleaf, indigenous women leaders from native people all over the world, Sinead O'Conner, Eileen Caddy, founder of the Findhorn Community, Anita Roddick, Katharine Hamnett, Robert Graves.

How did you get to where you are?
By keeping my vision of a new kind of world and society based on the feminine principles of community, connection and love.

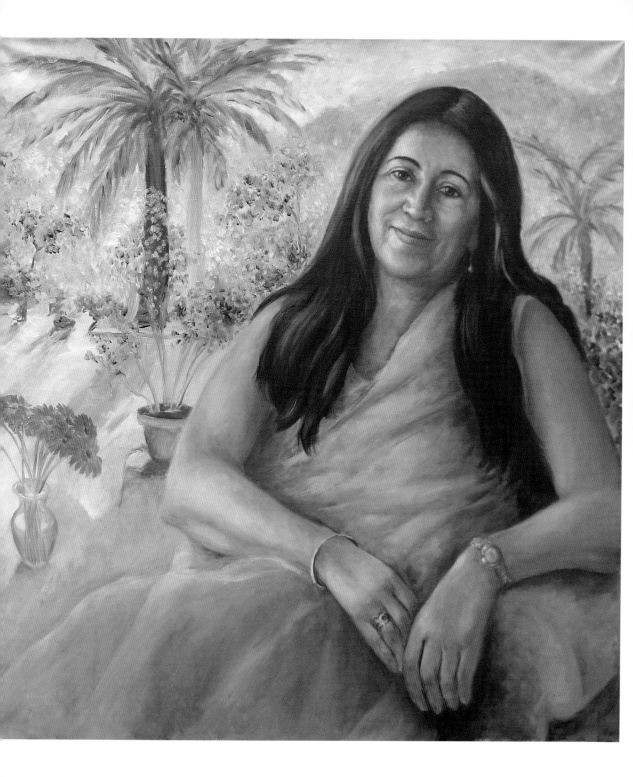

Clara Furse

FIRST FEMALE CHIEF EXECUTIVE OF LONDON
STOCK EXCHANGE

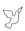

Clara Furse has been Chief Executive of the London Stock Exchange since February 2001. Prior to joining the Exchange, Clara was Group Chief Executive of Credit Lyonnais Rouse from 1998 to 2000. Clara's career has spanned a broad range of global financial markets. She began her career in 1979 as a broker, joining Phillips and Drew (now UBS) in 1983, becoming a Director of the company in 1988, Executive Director in 1992, Managing Director in 1995 and Global Head of Futures in 1996. In addition, she served as a board member and Deputy Chairman of LIFFE (1991—1999). Clara was educated at schools in Colombia, Denmark and Britain, she studied at the London School of Economics, speaks several European languages and lives in London with her husband and three children. She is a member of the Board of Euroclear plc, LCH. Clearnet and Fortis. She is also a Companion of the Chartered Management Institute, a member of the CBI President's Committee, the CBI Task Force on Climate Change and a Member of the Court of the Worshipful Company of International Bankers.

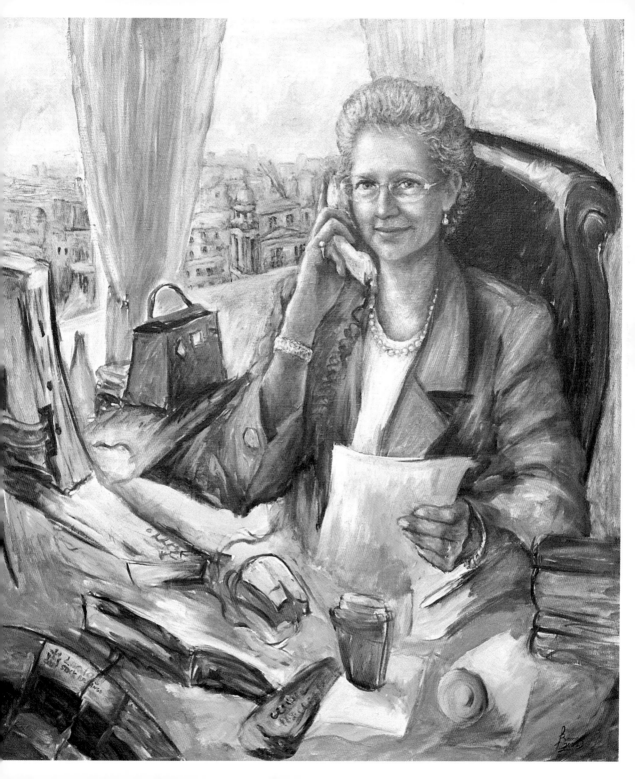

Dame Evelyn Glennie OBE

SOLO PERCUSSIONIST, COMPOSER, MOTIVATOR
AND ENTREPRENEUR

Evelyn was brought up on a farm in Aberdeenshire. Her first instruments were the mouth organ and the clarinet. Other influences were Glenn Gould, Jacqueline du Pré and Trilok Gurtu. She studied at Ellon Academy and the Royal Academy of Music. Evelyn is the first person in musical history to sustain a full-time career as a solo percussionist and gives more than 100 performances a year worldwide, performing with the greatest conductors, orchestras, and artists. Her diverse collaborators have included Björk, Bobby McFerrin, Sting, Kings Singers and Mormon Tabernacle Choir.

Evelyn has commissioned one hundred and forty six new works for solo percussion from many of the world's most eminent composers and is a BAFTA-winning composer of film and television music. Her CD, Bartok's Sonata for two Pianos and Percussion won her a Grammy in 1988. A further two Grammy nominations followed, one of which she won for a collaboration with Bela Fleck. Her autobiography, *Good Vibrations*, was a best-seller. She has collaborated with the renowned film director Thomas Riedelsheimer on a film called *Touch the Sound* and presented two BBC television programmes. Evelyn has lobbied the Government on issues as diverse as music education and parking rights for motorbikes (she is a keen biker). She has her own jewellery range and is an international motivational corporate speaker. Evelyn also performs with orchestras on the Great Highland Bagpipes. Her private teaching now allows her to explore the world of sound therapy as a means of communication.

In 1993 Evelyn was awarded the OBE (Officer of the British Empire). This was extended this year to 'Dame Commander' for her services to music, and to date has received approximately 80 international awards.

Describe yourself in 5 words.
Stubborn but flexible, focused, independent, single-minded, happy.

What are your top 5 to 10 survival tips?
Humour, keep quiet, patience with others, knowing that time is the biggest healer, confidence that everything always works out in the end.

What is your favourite work of art?
The paintings of my 5 year old niece.

What is your biggest obstacle that you have faced?
Impatience with myself in trying to do things.

What is your favourite word or words?
Sploosh.

Do you have a female role model?
My cat.

Who would you ask to a dinner party from history?
Beethoven. I'd like to show him modern hearing-aids, cochlear implants and other advancements for hearing-impaired people.

How did you get to where you are?
Creating really simple aims, focusing on them, surrounding myself with good people who do their job properly, being stubborn.

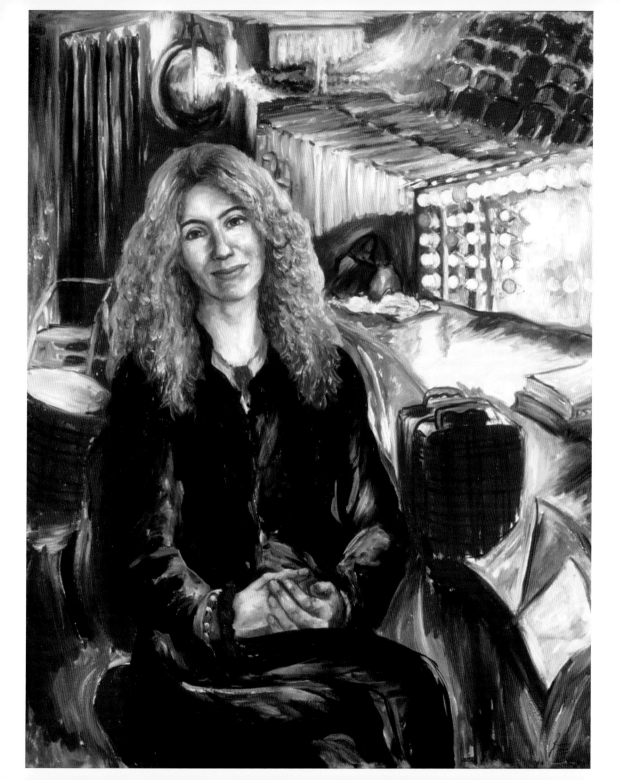

Baroness Susan Greenfield CBE

SCIENTIST, FIRST FEMALE DIRECTOR OF THE
ROYAL INSTITUTION

Baroness Greenfield is Director of the Royal Institution of Great Britain (the first woman to hold the position) and Professor of Pharmacology at the University of Oxford, where she leads a multi-disciplinary team investigating neurodegenerative disorders, as well as exploring the physical basis of consciousness. Born on 1/10/1950, her books include *'The Human Brain: A Guided Tour'* (1997), *'The Private Life of the Brain'* (2000), *'Tomorrow's People: How 21st Century Technology Is Changing the Way We Think and Feel'* (2003) and *'ID' The Quest for Identity in the 21st Century*–to be published by Hodder in May 2008.

Four companies have been formed as a result of her research and she has made a diverse contribution to print and broadcast media, and led a Government report on *'Women In Science'*. She has received 29 Honorary Degrees, Honorary Fellowship of the Royal College of Physicians (2000), a non-political Life Peerage (2001) as well as the Ordre National de la Legion d'Honneur (2003). In 2006 she was installed as Chancellor of Heriot-Watt University and voted 'Honorary Australian of the Year'. In 2007 she was made a Fellow of the Royal Society of Edinburgh.

Describe yourself in 5 words.
Impatient, enthusiastic, punctual, honest, iconoclastic.

What are your top 5 to 10 survival tips?
Sense of humour.
Being honest.
Not obsessing.
Being organised.
Not being perfect.

What is your favourite work of art?
Anything by Dali.

What is your biggest obstacle that you have faced?
Being a woman in science.

What is your favourite word or words?
Idea.

Do you have a female role model?
Rita Levi.

Who would you ask to a dinner party from history?
Shakespeare, Pericles, Euripides, Elizabeth I.

How did you get to where you are?
Being myself.

Sophie Grigson
COOKERY WRITER AND TV PRESENTER

Sophie Grigson is one of Britain's best-loved food-writers and television cooks. She is not a chef, but a keen champion of domestic cookery–in other words eminently practical, and keen on eating well. Her latest book is *Vegetables* (published by Collins 2006), and previous ones include *First Time Cook*, *Sophie Grigson's Country Kitchen*, *Eat Your Greens*, *Fish and Sunshine Food*. *Organic*, co-authored with William Black won a Jacob's Creek Hardback Recipe Book Award in 2003.

She has presented nine television series for the BBC, Channel 4 and UKTV Food. Sophie also writes for *Waitrose Food Illustrated*, *Country Living Magazine and Living Earth*, and demonstrates her recipes in all manner of places from the heady heights of Fortnum & Mason in London, to tents in fields in the middle of the English countryside. She is Patron of the Children's Food Festival, Chairwoman of the Jane Grigson Trust and was the President of the Herb Society. She shares her house with her two children, two cats and two snakes, lives near Oxford and hates ironing, liquorice and margarine.

Describe yourself in 5 words.
Contradictory–gregarious, loner, determined, procrastinator, loving/irritable.

What are your top 5 to 10 survival tips?
Grab lucky chances and run with them.
Treat everyone with consideration from cleaners and dustbin(wo)men to the bosses.
Check the small print. Twice.
Believe in yourself, but listen to criticism.
Learn the rules before you decide to break them.
Remember that money is merely a useful tool.
Take pleasure in what you have, instead of yearning for things you don't have.
Have fun but never at the expense of others.
Eat good food and enjoy it.

What is your favourite work of art?
If I had to save just one or two artworks when all around were being destroyed it would have to be drawings or paintings or sculpture that my children have made for me.

What is your biggest obstacle that you have faced?
Vesuvius.

What is your favourite word or words?
Hello and Goodbye. Least favourite is 'favourite', closely followed by crispy, tangy, toothsome, and moist.

Do you have a female role model?
Not just one, but here are the first few that come into my head: Simone de Beauvoir, Freya Stark, Australia's Maggie Beer and Stephanie Alexander.

Who would you ask to a dinner party from history?
I like to have friends sitting round my dinner table and that includes my family. A bunch of re-animated corpses would put me right off my food.

How did you get to where you are?
By fluke–I've never planned my career and I don't intend to start now.

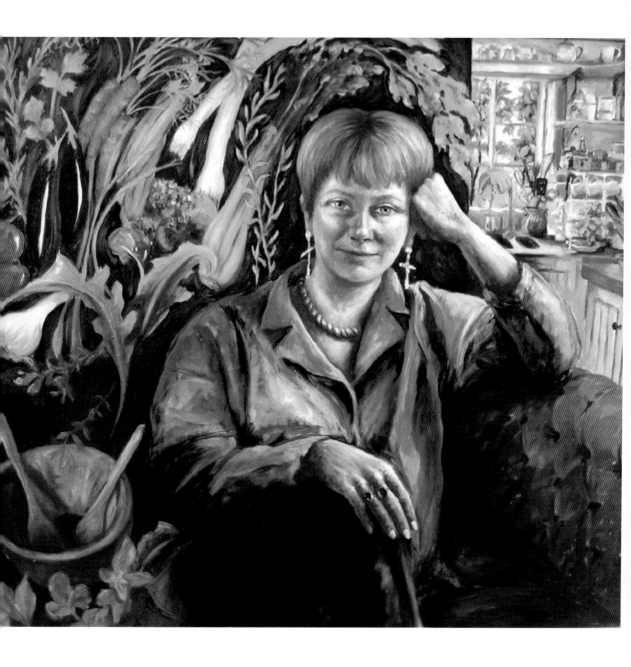

Caroline Hamilton

POLAR EXPLORER AND ENTREPRENEUR FOUNDER OF
ICEBREAKER INVESTMENT FUND

Caroline Hamilton is a record-breaking polar explorer and a successful businesswoman. She is part of the first all-women team to ski to both the North and South Poles. Hauling sledges more than her own body weight, she has travelled over 1500 miles through the Arctic and Antarctic. Caroline had led two previous expeditions but the journey to the North Pole in 2002 proved her most demanding yet. For 81 days she and her team-mates survived appalling polar conditions. The weather turned against them and they battled for weeks through fields of giant ice boulders, enduring temperatures of minus 45-50° Celsius. Their equipment froze and storms of 90 mph winds confined them to their tent for days at a time. So fierce was the wind at one point that the women were trapped under a tarpaulin on the open ice for 50 hours without food or heat, as they were buried alive under drifting snow. All the team suffered frostbite and Caroline and team-mate Ann Daniels were left to cover the last 330 miles in 30 days after fellow explorer Pom Oliver was airlifted out. At times they were forced to swim with their sledges through stretches of sub-zero sea water. Finally, after giving their all, they reached the North Pole on June 2nd 2002. Caroline has never failed to reach her goal.

Prior to 2002, she was the leader and driving force behind two other successful polar expeditions - the first all-women relay to the North Pole in 1997 and the first British all-women expedition to the South Pole in 2000. Caroline's story is one of courage and tenacity, of dealing with rapidly changing circumstances, focusing on a goal and building supreme trust in the people around you.

Describe yourself in 5 words.
Competitive, determined, bold, gregarious, risk-taker.

What are your top 5 to 10 survival tips?
Enjoy yourself and your surroundings.
Make other people laugh.
Realise it doesn't matter if you're frightened.
Take nothing for granted.
Think in an emergency.
Always warm your tampon up before you use it.

What is your favourite work of art?
Christchurch, Spitalfields.

What is your biggest obstacle that you have faced?
People who doubt.

What is your favourite word or words?
Supercalifragilisticexpialidocious.

Do you have a female role model?
No.

Who would you ask to a dinner party from history?
Jane Austen.

How did you get to where you are?
By taking opportunities and never giving up.

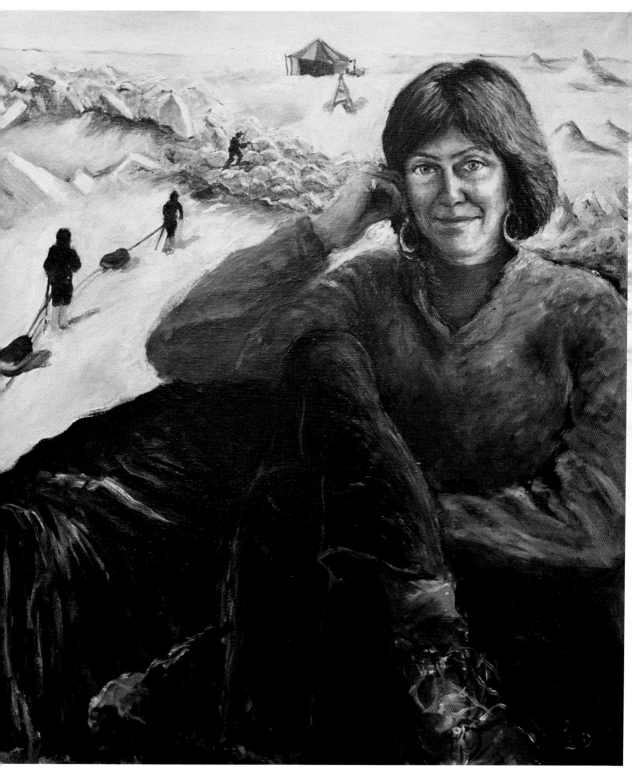

Kate Hoey

LABOUR MEMBER OF PARLIAMENT FOR VAUXHALL
SOUTH LONDON SINCE 1989

Kate Hoey has been the Labour Member of Parliament for Vauxhall, South London since a by-election in 1989. Kate was born in County Antrim, Northern Ireland where her parents were farmers. She attended the Belfast Royal Academy and the Ulster College of Physical Education before going on to take an Economics degree in London. During her student days she was elected a sabbatical Vice President of the National Union of Students. She has always been very interested in sport and was once the Northern Ireland High Jump Champion. She has worked for a number of football clubs including Arsenal, Tottenham Hotspur, Queens Park Rangers, Chelsea and Brentford as Educational Advisor. This involvement in sport, particularly football and cricket, has continued into her political career – and she is now an honorary Vice-President of Surrey County Cricket Club in her constituency.

Kate was appointed Parliamentary Private Secretary to Frank Field, Minister for Welfare Reform after the election of the Labour Government in 1997. Before the election she was a member of the Social Security Select Committee and the Broadcasting Select Committee. In July 1998 she was appointed as a Minister in the Home Office before becoming Sports Minister in 1999, a position she held until the 2001 General Election. She is very interested in foreign affairs –visiting Sarajevo at the height of the siege, monitoring the first democratic elections in Angola and visiting Zimbabwe undercover in 2003, 2005 and 2006 to investigate the deteriorating political and humanitarian crisis. Independent minded, she was one of the small number of Labour MPs who voted against a ban on hunting.

Describe yourself in 5 words.
Energetic, principled, slightly stubborn, happy.

What are your top 5 to 10 survival tips?
Frequent visits to childhood home in Northern Ireland, chocolate, good friends outside politics, sunshine, echinachia.

What is your favourite work of art?
A gift of a primrose painted by my best friend Rosemary Raddon.

What is your biggest obstacle that you have faced?
Death of my father.

What is your favourite word or words?
Outrageous.

Do you have a female role model?
My mother.

Who would you ask to a dinner party from history?
Eric Liddle, Dr David Livingstone, Queen Victoria.

How did you get to where you are?
Parents undertaking great sacrifices for me when young. A grammar school education and always doing what I thought was right even if unpopular.

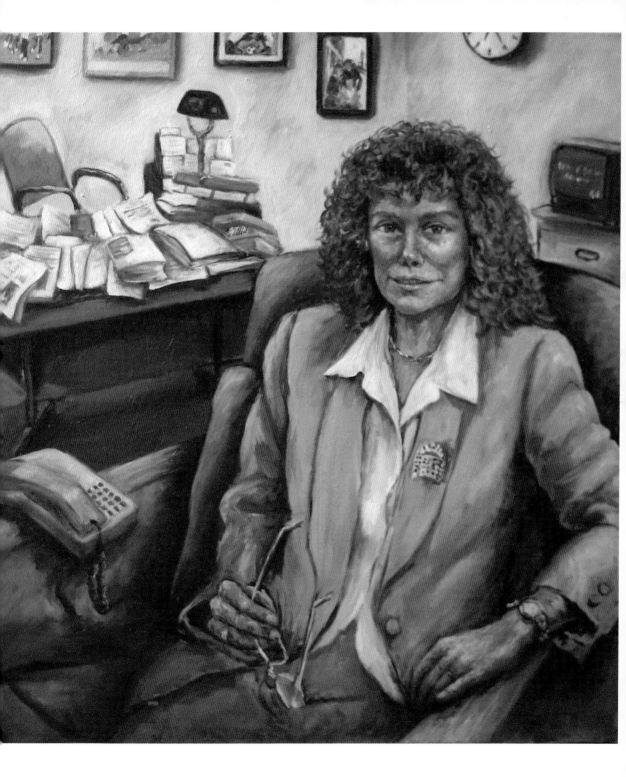

Lady Sue Woodford Hollick

CHAIR, ARTS COUNCIL ENGLAND, LONDON

S ue Woodford Hollick is a businesswoman and consultant with wide-ranging involvement in broadcasting and the arts. She is a former producer/director of "World in Action" for Granada Television and founding Commissioning Editor of multicultural programmes at Channel 4 television.

Sue has been Chair of Arts Council England, London since September 2000 and is currently a member of the Tate Modern Advisory Council. She is founder and Co-Director of Bringing Up Baby, a childcare company. She has recently taken over the Chair of the UK board of AMREF, Africa's largest NGO and leading health development charity.

Sue Woodford-Hollick is married to the Labour peer and founder of Channel 5, Clive Hollick. She has three daughters, one granddaughter and a grandson. Her passions include television, the arts, cinema, tennis and golf.

Describe yourself in 5 words.
Feisty, fit, forthright, focused, fallable.

What are your top 5 to 10 survival tips?
Exercise regularly.
Have fun.
Drink red wine.
Laugh.
Work hard at a job you enjoy.
Stay close to family and friends.

What is your favourite work of art?
Anything by Chris Ofilli.

What is your biggest obstacle that you have faced?
Miserable childhood.

What is your favourite word or words?
Can do!

Do you have a female role model?
Aung San Suu Kyi.

Who would you ask to a dinner party from history?
Martin Luther King.

How did you get to where you are?
Luck and bloody mindedness.

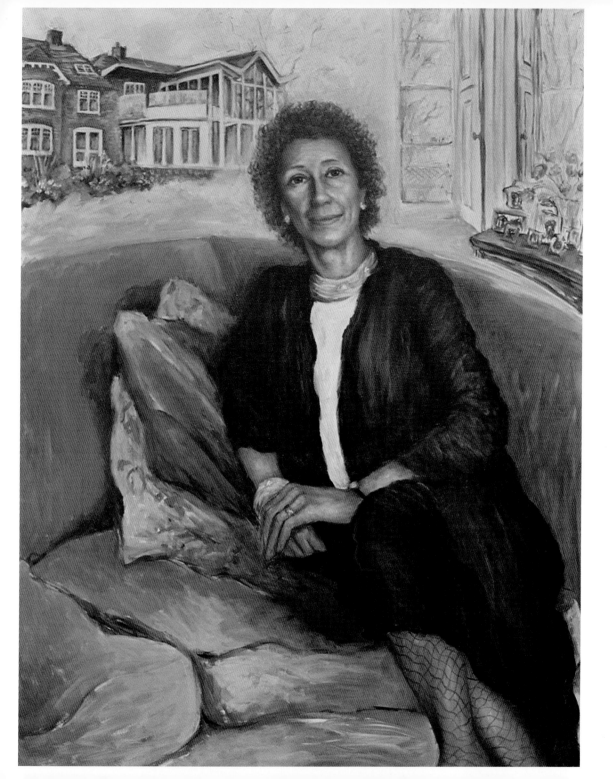

Catherine Hughes CMG, MA

PRINCIPAL OF SOMERVILLE COLLEGE, OXFORD 1989—1996

Catherine was born in London in September 1933, the youngest of three. During the Second World War she spent a happy time at Leeds Girls' Grammar School (the privilege, for those without resources, of living in the era of the Grammar School). By the 1950's a scholarship took her to St Hilda's college Oxford and three years of history and friendship. Her results gained her entry to the Foreign Office in 1955 – still unusual for a woman but not unprecedented (the first woman ambassador was appointed in those years). There followed decades of engrossing and, in her words, amusing work. Her first foreign posting to The Hague confirmed her as a European. Bangkok and Vientiane in the build up to the Vietnam war was a shock lesson in the lack of rigour and honesty in the thinking of great powers. Paris restored her faith in the goodness of life. Years observing the Sterling Agreements and the character of the City and treasury were salutary. Then the fascination of East Berlin, the Nazi past, sterile communism, the flagrant prosperity of the West, followed by two years in the Cabinet Office, two years travelling the world as a Foreign Office Inspector, more years in Bonn as Minister (Economic) and then as AUS in the FO, she served in the Diplomatic Service 1955—1989.

London life always included links with old friends, not least those in Oxford, and she relinquished a life always on the move to take up the post of Principal of Somerville College (1989—1996). There was still time for new friendships and by 1991, she married the acting Warden of Green College, Dr J Trevor Hughes, gaining three step-sons and has latterly enjoyed travelling and having time for old friends.

Describe yourself in 5 words.
Argumentative, European, happy, friend-friendly.

What are your top 5 to 10 survival tips?
Never despair–stop and think, you always know more than you think.
Do what can be done–it always leads to more than you expect.
Keep spirits buoyant by having an antidote to hand, e.g. if sweating in the topics read the Brontes.

What is your favourite work of art?
Holbein–Edward VI as a Child.
Georges Roualt–The Old King.

What is your biggest obstacle that you have faced?
My liking for idleness.

What is your favourite word or words?
Subtlety, understanding, imagination, wit.

Do you have a female role model?
No.

Who would you ask to a dinner party from history?
St. Hilda of Whitby, the Venerable Bede, Colbert, the Marquis de Moleville, George Eliot, Thomas Babington Macaulay.

How did you get to where you are?
Luck and the enjoyment of a wide range of activity.

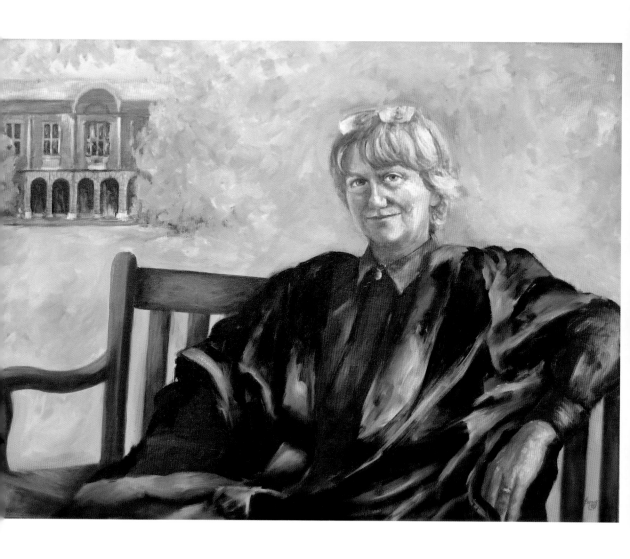

Baroness PD James OBE

AUTHOR

Crime novelist Baroness PD James was born in Oxford in 1920, the eldest daughter of an Inland Revenue Official. The family moved to Cambridge when she was 11, where she attended the Cambridge High School for Girls. She worked for the National Health Service (1949—68) and the Civil Service until 1979 when she began to write full-time. She was a Governor for the BBC (1988-93), and Chairman of the Literature Advisory Panel at both the Arts Council of England (1988-92) and the British Council (1988-93). She was awarded the OBE in 1983 and created a Life Peer (Baroness James of Holland Park) in 1991.

Baroness James is also a Fellow of the Royal Society of Literature, a Fellow of the Royal Society of Arts, and chaired the Booker Prize Panel of Judges in 1987. She has been President of the Society of Authors since 1997. She has received the following honorary degrees: Doctor of Letters from the Universities of Buckingham 1992; Hertfordshire 1994; Glasgow 1995; Durham 1998, Portsmouth 1999. Doctor of Literature from the University of London 1993; Doctor of the University, Essex 1996. She was made an Associate Fellow of Downing College, Cambridge (1986) and an Honorary Fellow (2000). She is also an Honorary Fellow of St Hilda's College, Oxford (1996) and of Girton College, Cambridge (2000).

Her novels include a series featuring the Scotland Yard policeman Commander Adam Dalgliesh. Her latest Commander Dalgliesh mystery is *The Lighthouse* (2005). PD James has been awarded major prizes for her crime writing in Great Britain, America, Italy and Scandinavia. In 1999 she received the Mystery Writers of America Grandmaster Award for long term achievement. She is published widely overseas including the USA, Canada, France, Germany, Italy, Spain, Japan, Holland, Norway, Denmark, Sweden, Finland, Portugal, Hungary, Czechoslovakia and Argentina.

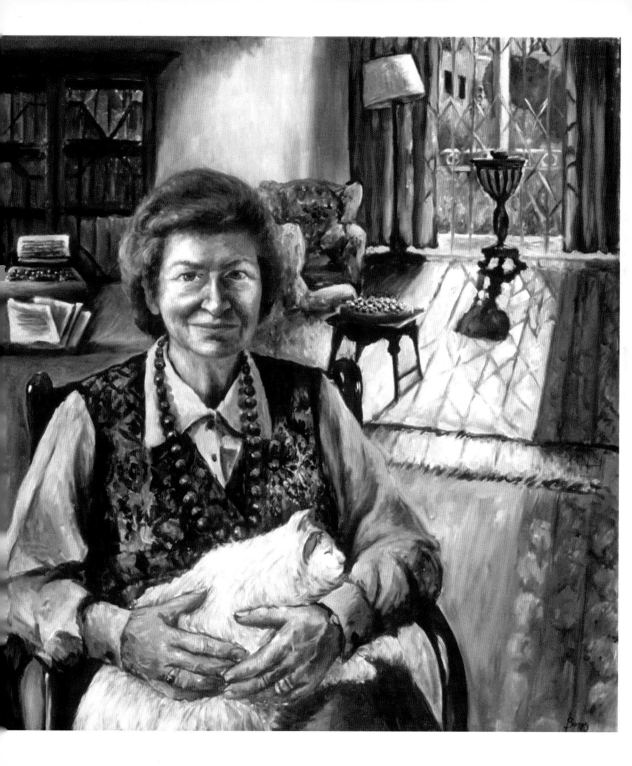

Sarah Kent

ART CRITIC

Sarah Kent is an enormously influential figure in the contemporary British art scene and was an early supporter of artists such as Damien Hirst, Sarah Lucas and Tracey Emin who became known as the YBAs (Young British Artists). She has always championed artists and writers at the beginning of their careers, especially women, in a country that, until recently, has been fundamentally hostile to contemporary art. She studied painting at the Slade School of Art and continued to be a practising artist until 1977, when she became Director of Exhibitions at the ICA. Over the next two years she staged over 50 exhibitions by established figures such as Andy Warhol, Christo and Allen Jones and younger, less well known artists such as Michelle Stuart, Jeanne Masoero, Amikam Toren, Shelagh Wakely and Alexis Hunter. She is best known, though, as the Visual Arts Editor of the London listings magazine, Time Out–for decades the only publication to review exhibitions in the capital's commercial and fringe galleries while still on show and therefore a highly influential outlet. After thirty years she finally left the magazine in November, 2006 to work freelance as a writer, lecturer and broadcaster. She has written catalogues for many galleries including the Hayward, ICA, Saatchi, White Cube and Haunch of Venison and books such as *Shark-Infested Waters: The Saatchi Collection of British Art in the 90's*. She has been on numerous juries including the Turner Prize and is a controversial figure, receiving praise and criticism alike for her uncompromising views.

Describe yourself in 5 words.
Bright, energetic, hard-working, optimistic, fiercely independent.

What are your top 5 to 10 survival tips?
Take responsibility, don't even think of relying on anyone else, believe that anything is possible but be realistic, don't waste time and energy harbouring regrets, look forward and don't indulge in nostalgia, yet live for today. Act honourably and be loyal so you can have a clear conscience. Take everything in your stride.

What is your favourite work of art?
Las Meninas *by Velasquez.*

What is your biggest obstacle that you have faced?
Being a single parent, misogyny.

What is your favourite word or words?
'My dreams said one to another "This life has let us down"'.

Do you have a female role model?
A combination of my mother (intelligent, ambitious, competitive, got things done) and her mother (a kind, matronly Victorian battle axe).

Who would you ask to a dinner party from history?
Women artists–Artemisia Gentileschi, Freda Kahlo, Suzanne Valadon, Gwen John and Louise Bourgeois.

How did you get to where you are?
Enthusiasm, intelligence, determination, commitment, nerve, optimism, skill, application, luck, looks, endurance, usually saying yes.

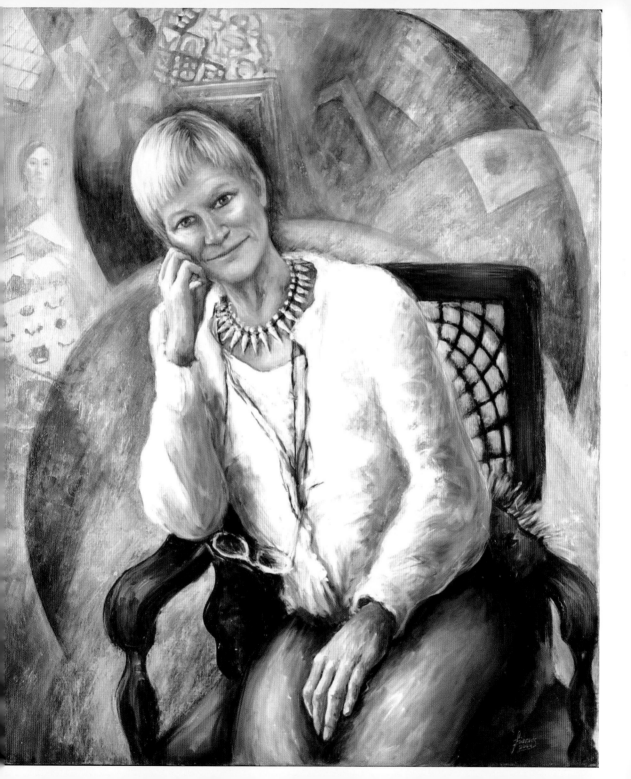

Beverley Knight MBE

SINGER/SONGWRITER

orn in Wolverhampton in 1973, Beverley's club classic debut
Flavour of the Old School, burst on to the UK urban scene
of 1995. Post her 1995 indie label debut album *The B Funk*,
each of her gold albums, 1998's *Prodigal Sista*, 2001's *Who I Am*
and 2004's *Affirmation* has contained at least three top 40 hits. In
fact the 12 top 40 hits on 2006's *Voice–The Best of Beverley Knight*
chart her talents as vocalist and songwriter over a decade that
saw many styles come and go. The album entered the top ten in
March 2006 and has gone platinum. Following the success of *Voice*
Beverley recorded her fifth studio album *Music City Soul* at the
end of 2006, with acclaimed producer Mark Never, in Tennessee,
Nashville, with Rolling Stone Ronnie Wood playing guitar on
three tracks. *Music City Soul* has been Beverley's most critically
acclaimed album so far, followed by her biggest UK tour to date,
marking the height of her career by playing to 3,500 fans at The
Royal Albert Hall.

One of Beverley's proudest moments was being awarded an
MBE in 2007 for services to music. She has won three Mobo
awards, as well as Mercury and Brit nominations, and has sung
by invitation for many celebrated fans including David Bowie,
Mohammed Ali, Nelson Mandela and the G8 leaders. Beverley
also supported Take That on their comeback tour last year.
She has sung on stage with artists from Prince, Chaka Khan to
Bryan Adams and recorded with Musiq Soulchild, Jay Kay, Jools
Holland and Courtney Pine, to name a few. Arguably the pinnacle
of her career was being invited by Prince to support his 21 date
summer tour in 2007, she also sang with him for two blistering
hours at both of his incredible after-shows.

Describe yourself in 5 words.
Passionate, childlike, optimistic, warm, impulsive.

What are your top 5 to 10 survival tips?
*Like Curtis Mayfield sang "keep your head to the
sky". You never know what joy awaits you around
any given corner.
Don't smoke! It ages you dahling!
Greet everyone with a smile, it's infectious and it
disarms miserable gits.
Work real hard, play harder.
When that little but powerful voice inside your
head starts talking, listen. Instinct saves us all at
least once in our lives.
Look after your heart!*

What is your favourite work of art?
*I have a copy of a Basquiat self portrait at home.
It is intense, full of contradiction. His sketching
seems frenzied, aggressive even and yet his outward
appearance is cool, self-assured, aloof.*

**What is your biggest obstacle that you have
faced?**
*Learning to accept that as a mere human, I can't b
full of energy and creativity 24/7. I push myself to
be "on" all the time, I have mellowed with age.*

What is your favourite word or words?
*Buntin, bunny rabbit and fandangle...told you, I'v
a kid really.*

Do you have a female role model?
*My mum is the single most important role model in
my life. She has an inner strength that bedazzles me*

**Who would you ask to a dinner party from
history?**
*Sam Cooke. The first recorded voice I ever heard.
The father of soul. As a child, I was mesmerized by
his gospel singing. I want to know what made him
sing that way. He was the first, and the best.*

How did you get to where you are?
*I walked a long narrow road, and paid serious
dues to get to this point, and believe me, I'm still
walking.*

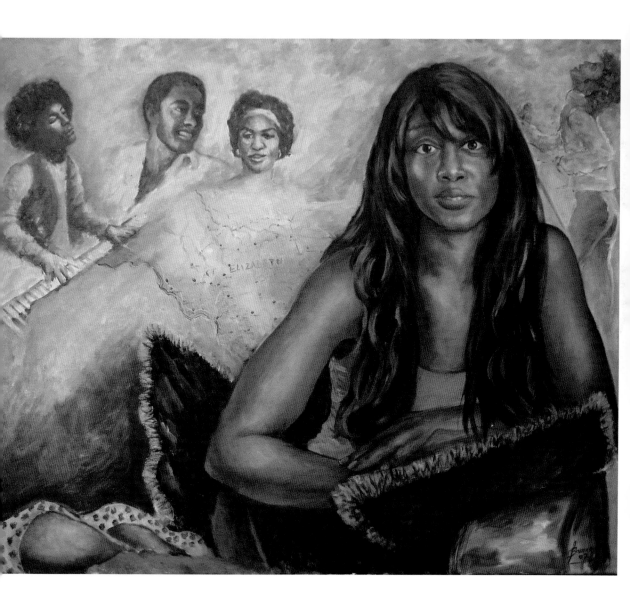

Kathy Lette

AUTHOR

Kathy Lette first achieved 'succces de scandale' as a teenager with the novel *Puberty Blues*, a strongly autobiographical, proto-feminist teen novel about two 13-year-old southern suburbs girls attempting to improve their social status by ingratiating themselves with the "Greenhill gang" of surfers, co-written with friend Gabrielle Carey. The book was made into a successful movie in 1981 by Bruce Berestford. After several years as a newspaper columnist in Sydney and New York (collected in the best selling *"Hit and Ms"*) and television sitcom writer for Columbia Pictures in Los Angeles, she wrote the internationally best selling *The Llama Parlour* (1991), *Foetal Attraction* (1993), *Mad Cows* (1996–also made into a motion picture staring Joanna Lumley and Anna Friel), *Altar Ego* (1988), *Nip'N'Tuck* (2001), *Dead Sexy* (2003) and *How To Kill Your Husband (and other handy household hints)*, soon to be a series on ITV. Kathy's plays include *Grommits, Wet Dreams, Perfect Mismatch* and *I'm So Happy For You I Really Am*. Her novels have been published in over 100 countries and fourteen languages.

Kathy lives in London and is married to a fellow Australian expatriate, QC Geoffrey Robertson, also a television host and author, whom she first met when appearing on his *Hypotheticals* panel debate show. They have two children, Julius and Georgina. Kathy has just finished a stint as writer in Residence at London's Savoy Hotel. She says that the best thing about being a writer is that you get to work in your jammies all day, drink heavily on the job and have affairs and call it research! (although her husband says he should have the affair as it would give her a better book!).

Describe yourself in 5 words.
Demented working mother (surely a tautology?)

What are your top 5 to 10 survival tips?
Don't wait to be rescued by a Knight in shining Armani.
Learn to stand on your own two stilettos.
Love your husband, adore your husband...but get as much as you possibly can in your own name!
Don't have the epidural, because crapping on the obstetrician is the ultimate revenge.
Any woman who calls herself a post feminist, has kept her wonder bra and burnt her brains.

What is your favourite work of art?
Everything and anything by Paula Rego...I have no artistic talents, but I do have a tendency to paint myself into a corner on a regular basis.

What is your biggest obstacle that you have faced?
The profound misogyny which still exists in our working lives. Women still don't have equal pay (we're getting 75 pence in the pound) and are still getting concussion from hitting our heads on the glass ceiling, plus we're expected to windex it while we're up there.

What is your favourite word or words?
Thesaurus–but why is there no other word for it?

Do you have a female role model?
My mother–for giving birth without an epidural. (A case of stiff upper labia.) If ever you had any doubt about the gender of god, when giving birth you realise that he's a bloke!

Who would you ask to a dinner party from history?
Dorothy Parker, Becky Sharpe, Mae West, Oscar Wilde, Simone De Beauvoir, Germaine Greer, Madonna, Jane Austen, Emily Pankhurst.

How did you get to where you are?
Um...I caught a plane from Sydney's Mascot airport, then a tube from Heathrow.

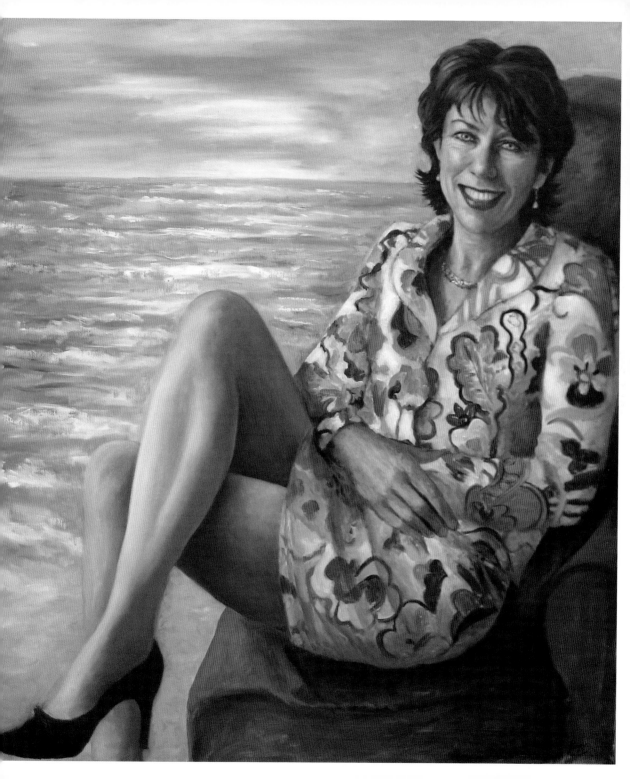

Maureen Lipman CBE

ACTOR

Hull-born Maureen Lipman studied Drama at LAMDA and joined Laurence Olivier's Company and the RSC. Her West End runs include *Candida, Outside Edge, See How They Run* (Olivier Award), *Wonderful Town, The Cabinet Minister, Lost In Yonkers* (Variety Club Award), *The Sisters Rosenweig, Re:Joyce!, Oklahoma!, Peggy for You, The Vagina Monologues, Thoroughly Modern Millie, Aladdin* at the Old Vic and *Glorious*. In 1997, her one-woman show, *Live & Kidding* was nominated for an Olivier Award. In March 2001 Maureen appeared in daughter Amy Rosenthal's play *Sitting Pretty*, in New York.

Her TV comedies include: *Agony, All At No 20* (TV Times Award) and *About Face*. She appeared in husband Jack Rosenthal's *The Evacuees* and *The Knowledge, Eskimo Day* and the sequel *Cold Enough For Snow*, Ayckbourn's *Absurd Person Singular* and *Absent Friend*s, *The Little Princess* and *Outside Edge* and *Coronation Street*. A Best of British documentary for BBC1 on her life and career was shown in 1999.

Her films include: *Up the Junction, Educating Rita, Carry on Columbus, Captain Jack, Solomon and Gaenor* (Oscar-nominated Welsh/Yiddish) and Polanski's *The Pianist* (Cannes Palme d'Or).

She has presented for the BBC: First Sight's *Hampstead on the Couch* and *George Eliot–A Scandalous Lif*e. As a writer for *Options, She* and *Good Housekeeping* she has been PPA Columnist of the Year. She has written six best-sellers: *How Was It for You?, Something to Fall Back On, You Got An 'Ology, Thank You For Having Me, When's it Coming Out* and *You Can Read Me like a Book*. Her latest are *Lip Reading* and *The Gibbon's in Decline but the Horse is Stable*–an anthology of humorous animal poems. She wrote her late husband's biography By Jack Rosenthal in 2005 and directed, produced and played herself in Rosenthal's *Last Act*, for Radio 4 in 2006. She was married to Rosenthal for 31 years. Their children, Amy and Adam are both writers.

Describe yourself in 5 words.
Insecure, gregarious, witty, affectionate, verbally incontinent.

What are your top 5 to 10 survival tips?
Supper once a week with the family.
Rosa Moqueta oil.
Propolis–natural anti-biotic from bees for chest colds and Combination J tissue salts.
I nurture my friends.
Radio 4.

What is your favourite work of art?
It changes; as of this week the Anthony Gormley exhibition at the Hayward gallery and Harry Black's stained glass windows in the Honan Chapel, Cork.

What is your biggest obstacle that you have faced?
Bereavement.

What is your favourite word or words?
How do I love thee?
Let me count the ways...
...I love thee with a love I seemed to lose with my lost saints
And if God choose, I shall but love thee better after death.

Do you have a female role model?
Elizabeth Barrett Browning.

Who would you ask to a dinner party from history?
Aung San Suu Kyi, Golda Meir, Carol Shields Bill Clinton, KD. Lang, George Burns and Gracie Allan, Louise Brooks, Jeff Bridges, Linda Agran, Florence Foster Jenkins, Bach, Humphrey Lyttleton, Jo Brand, King David, Judy Holiday, Fred Astaire, Shrek, Jesus, Rabbi Hugo Gryn, Jack Rosenthal.

How did you get to where you are?
Ambition, hard work, ability, low cunning, instinct.

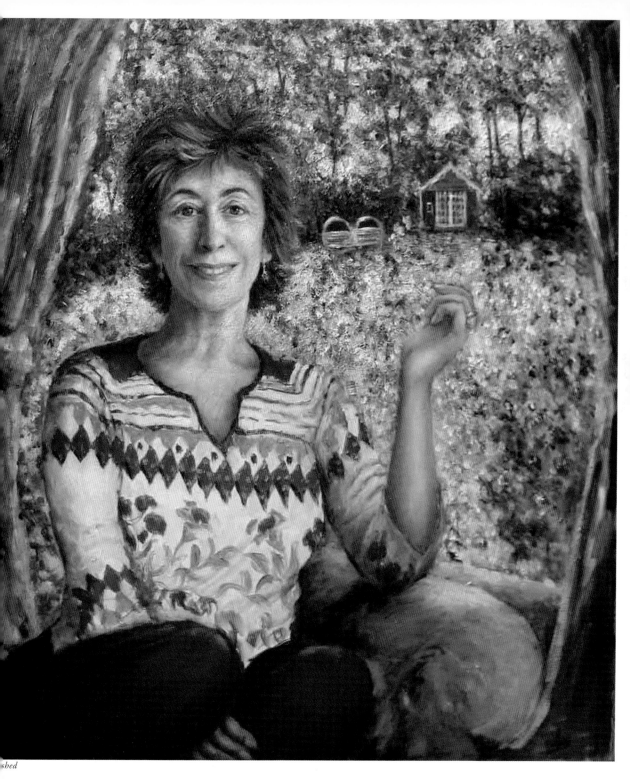

shed

Her Honour Nina Lowry

FIRST PERMANENT WOMAN JUDGE AT THE OLD BAILEY

Her Honour Noreen (Nina) Margaret Lowry, nee
Collins, was born in London in September, 1925. She
was educated at Bedford High School, and attended
Birmingham University, reading law. She was called to the Bar
in 1948, practising criminal law on the South Eastern Circuit. In
1967, she was made a Metropolitan Stipendiary Magistrate and
sat at West London Magistrates' Court. In 1976 she was made a
Circuit Judge and from 1979 she sat at the Central Criminal Court
until her retirement in 1995, sitting in Court Number 11, next to
her husband, HHJ Richard Lowry, QC in Court 12.

After retiring from the Bench, she joined the Criminal Injuries
Compensation Board until 2000.

She was made a member of the Criminal Law Revision
Committee in 1975. She became a freeman of the City of London
in 1985, and in 1992 she received an Honorary Doctorate from
Birmingham University. She was made a Bencher of Gray's Inn in
1995.

She married Sir Edward Gardner QC in 1950 and they had a
son and daughter. In 1963 she married His Honour Richard John
Lowry QC and they had a daughter.

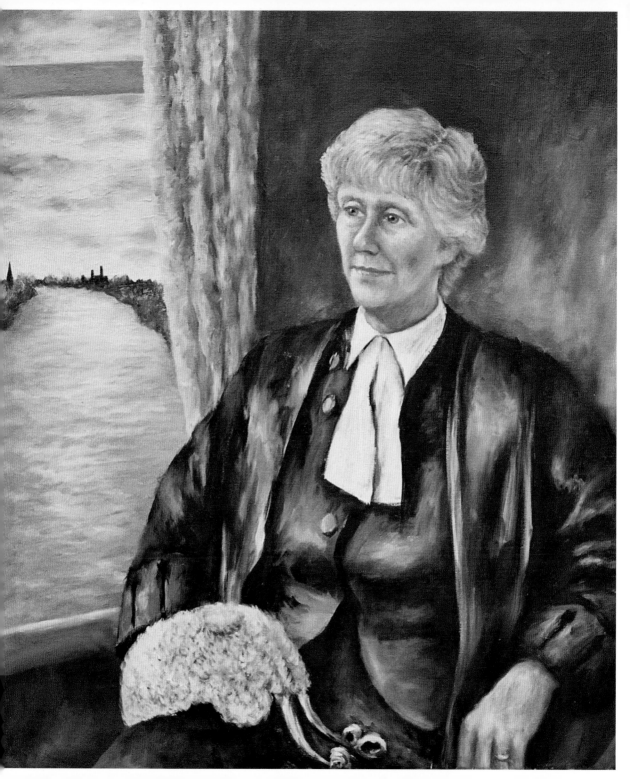

Doon Mackichan

ACTOR, WRITER

Doon's prolific career began on the comic circuit where she spent eight hilarious years (her last gig was the Reading Rock Festival) before she was snapped up into television. She is best known for her comedy work including double Emmy Award winning *Smack The Pony* (Talkback for Channel 4), the sitcom *Beast* (BBC 1), *The Day Today* (Talkback for BBC), *Knowing me, Knowing You* with Alan Partridge (Talkback for BBC) and many of the Comic Strip films (BBC2).

Her no less impressive theatre credits include "Gretchen" in *Boeing Boeing* at The Comedy Theatre, the part of The Wife in *A Respectable Wedding* at The Young Vic, directed by Joe Hill-Gibbins, Princess Diana in *The Queen and I* at the Royal Court, directed by Max Stafford-Clark, *Sacred Heart* and *Killers,* directed by Ian Rickson (both also at the Royal Court), Helena in *A Midsummer Night's Dream* at the Almeida and International tour, and *Mother Courage* at the National Theatre directed by Jonathan Kent.

Film credits include: *The Borrowers* (directed by Peter Hewitt), *With or Without You* (directed by Michael Winterbottom), and *Thanks for the Memories* (directed by Declan Lowney).

Doon's radio and cartoon work is extensive. Some of her best known work includes *Doon your Way* (BBC Radio 4), *Stressed Eric* (BBC), and *Bob and Margaret*.

In 2007 Doon finished a pilot in Africa for a comedy drama series for the BBC called "Taking the flak", which is due to begin filming this year.

Describe yourself in 5 words.
Brave, bossy, sentimental, joyful, wild.

What are your top 5 to 10 survival tips?
Keep getting up.
Cold water swimming.
Find the best in everything and everyone.
Be frivolous and sensual.
Be of service.
"The sea doth wash away all human ills."
Euripides.
Spend more time in nature.

What is your favourite work of art?
Anything by Paula Rego or Egon Schiele.

What is your biggest obstacle that you have faced?
Louis being diagnosed with Leukemia aged 9, and what he had to suffer to get to remission.

What is your favourite word or words?
GET IN!

Do you have a female role model?
All the mothers I got to know who lost their children to cancer and who carried on getting up.

Who would you ask to a dinner party from history?
Jesus and Judas.

How did you get to where you are?
By jumping in, mostly with no clothes on.

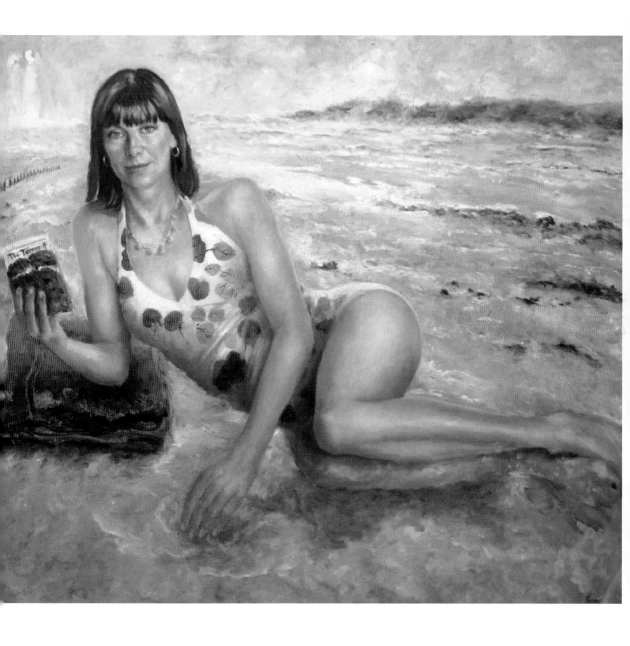

Baroness Genista McIntosh

FORMER EXECUTIVE DIRECTOR OF THE
ROYAL NATIONAL THEATRE

Genista (Jenny) McIntosh has held a number of senior positions in major arts organisations. Most recently she was the Principal of Guildhall School of Music & Drama (2002/2003). She was Executive Director of the Royal National Theatre between 1990 and 1996 and again between 1997 and 2002, and was briefly Chief Executive of the Royal Opera House in 1997. Between 1972 and 1984, and again between 1986 and 1990, she held a number of posts at the Royal Shakespeare Company. She was a founder Trustee of NESTA (National Endowment for Science, Technology and the Arts) from 1998 to 2005 and currently serves on the Boards of the Foundation for Sport and the Arts, the Theatres Trust, Southbank Sinfonia, the Roundhouse Trust, the National Opera Studio, the Almeida Theatre and Welsh National Opera. Genista holds Honorary Doctorates from the University of York (1998), the University of Middlesex (2002) and City University (2002) and received an Honorary Fellowship from Goldsmiths College, University of London in 2003. She is also a Fellow of the Royal Society of Arts. In 1999 she was created a Life Peer taking the title Baroness McIntosh of Hudnall.

Describe yourself in 5 words.
Mother, (expectant) grandmother, friend, gardener, opera-nut.

What are your top 5 to 10 survival tips?
Plan ahead.
Be prepared to abandon plans.
Keep the larder well stocked.
Keep friendships in good repair.
Unpack the kettle first.

What is your favourite work of art?
Miss Mary Edwards by Hogarth; Frick Museum, New York.

What is your biggest obstacle that you have faced?
Myself.

What is your favourite word or words?
Home.

Do you have a female role model?
George Eliot.

Who would you ask to a dinner party from history?
Richard Brinsley Sheridan, George Eliot, William Thackeray, Gertrude Jekyll, Jacqueline Du Pré (who would play for us after dinner).

How did you get to where you are?
A combination of good luck, good friends and occasional inspiration.

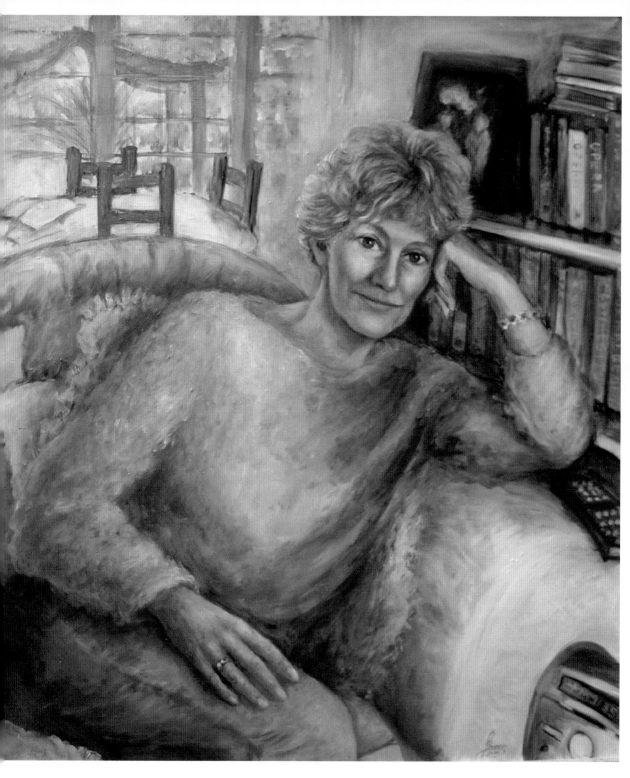

Dame Julie Mellor DBE

PARTNER PRICEWATERHOUSE COOPERS.
PREVIOUSLY, CHAIR EQUAL OPPORTUNITIES COMMISSION

Dame Julie Thérèse Mellor, DBE was born in 1957. Julie chaired the Equal Opportunities Commission from 1999 to 2005. She was Corporate Human Resources Director for British Gas and has 20 years experience of human resources management in a wide range of environments, from the Greater London Council to Shell and TSB. She chairs Fathers Direct (the national information centre on fatherhood, aimed at supporting fathers and their families) and sits on the boards of the Employers Forum on Disability and the Green Alliance. She is a former Commissioner of the Commission for Racial Equality. She is a partner at PricewaterhouseCoopers. She was made a Dame in 2006 for services to Equal Opportunities.

Describe yourself in 5 words.
I want to make a difference.

What are your top 5 to 10 survival tips?
Be clear on your direction then you can jump at opportunities when they come up, eat well, take holidays, enjoy the here and now.

What is your favourite work of art?
Face carvings and a temple at Angkor in Cambodia.

What is your biggest obstacle that you have faced?
Not going to bed.

What is your favourite word or words?
Unconditional love.

Do you have a female role model?
My mother.

Who would you ask to a dinner party from history?
Queen Elizabeth I.

How did you get to where you are?
With very supportive family, partner and children and passion for what I was doing.

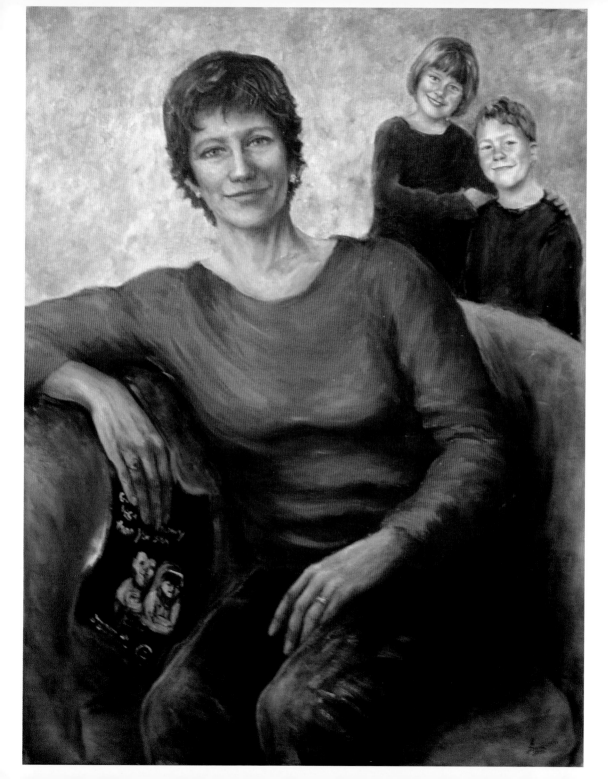

Jenni Murray OBE
Presenter, Woman's Hour

Jenni Murray has been the regular presenter of Radio 4's Woman's Hour since 1987. She also presents Radio 4's The Message. She was born in 1950 in Barnsley. She has a degree in French and Drama from Hull University. Jenni also has a number of Honorary Doctorates from the Universities of Hull, Bristol, London Metropolitan, Sheffield Hallam, St Andrews, Bradford, Huddersfield and the Open University. Jenni joined BBC Radio Bristol in 1973. She went on to be a reporter and presenter for BBC TV's *South Today* in 1978, where she worked until 1983 when she joined *Newsnight*.

She moved to Radio 4 in 1985 as a presenter for the *Today* programme and launched the Saturday edition of the programme with John Humphrys in 1987. Jenni is the author of *The Woman's Hour, A History of Women Since World War II, Is It Hot In Here; A Modern Guide to the Menopause* and *That's my boy* – a parent's guide to raising a happy confident son. She was a weekly columnist for the *Daily Express* from 1998 to 2000 and now contributes to a number of publications including *The Guardian, Daily Mail* and *Good Housekeeping.*

Jenni's interests include riding horses, the theatre, needlepoint and knitting. She is patron of the Family Planning Association, president of the Fawcett Society and vice president of the Parkinson Disease Society. In the Queen's Birthday Honours of 1999 she was awarded an OBE for radio broadcasting. Jenni has been open with her listeners about her recent diagnosis with breast cancer and has returned to broadcasting following her successful treatment, using her experience, as ever, as a forum for discussion and debate.

Describe yourself in 5 words.
Plump, workaholic, passionate mother and bookworm.

What are your top 5 to 10 survival tips?
Have a well stocked mind.
Nurture and value friends.
Work and play hard.
Stay close to your children.
Don't suffer fools.

What is your favourite work of art?
Manet's Déjeuner sur l'Herbe.

What is your biggest obstacle that you have faced?
Breast cancer.

What is your favourite word or words?
The cheque's in the post.

Do you have a female role model?
Baroness Williams.

Who would you ask to a dinner party from history?
Queen Elizabeth I.

How did you get to where you are?
Luck, hard work and my mother's insistence on elocution lessons!

Dame Elizabeth Neville DBE, QPM

FORMALLY CHIEF CONSTABLE, WILTSHIRE CONSTABULARY
SECOND COMAN EVER TO BE CHIEF CONSTABLE

Elizabeth Neville's career in the police service culminated as Chief Constable of Wiltshire Constabulary. Her professional life has been dedicated to the prevention and detection of crime. Following her degree studies she joined initially the Metropolitan Police progressing through the ranks of "the Met" and then served in Thames Valley Police, Sussex Police and Northamptonshire Police to become the first woman to hold the rank of Deputy Chief Constable.

In 1997 she joined Wiltshire Constabulary, becoming at the time the youngest Chief Constable. Throughout her career she has had senior responsibilities embracing crime and community affairs, personnel and training, complaints and discipline, IT, finance and property services and facilities. She was the Director of the Police National Assessment Centre in charge of selection of high potential officers, is a former member of the Police Leadership Development Board, chaired the Police Service Media Advisory Group and has been active in promoting opportunities for women in the police service. She was Vice President of the Police Mutual Assurance Society and is a member of the selection board for Fulbright Fellowships for officers to research policing issues. She has chaired the UK Police Men and Women Hockey Sections and was a member of the Board of Police Sport UK. She is a trustee of local and national charities, notably to help elderly or vulnerable people at risk from burglary and victims of domestic violence. She was awarded the Queen's Police Medal and is a Dame Commander of the British Empire.

Born in 1953, Dame Elizabeth is married with two children and two step children and lives in Wiltshire.

Describe yourself in 5 words.
Middle aged, hard working, active, friendly, sociable, strong minded . Asked my husband: he only had one word: 'nightmare'.

What are your top 5 to 10 survival tips?
Get enough sleep, take holidays, see your old friends, laugh, take time for yourself.

What is your favourite work of art?
Winged Victory of Samothrace. *Before they built the new extension to the Louvre, when you went in the old entrance, it was the first piece of art you saw, half way up the main staircase.*

What is your biggest obstacle that you have faced?
My own fear–trying to overcome it all the time.

What is your favourite word or words?
Hooligan, diaspora, serendipity.

Do you have a female role model?
The women in my family.

Who would you ask to a dinner party from history?
Hannibal the Carthaginian.

How did you get to where you are?
Mainly hard work and determination. I was brought up with the idea that I should have a career and that being unconventional was not a bad thing.

Dame Bridget Ogilvie AC, DBE, FRS

MEDICAL SCIENTIST DIRECTOR OF THE
WELLCOME TRUST 1991—1998

Dame Bridget was born in 1938 in New South Wales and is one of the UK's leading medical scientists. She grew up on her family's sheep station and studied science at the University of Queensland, joining the first group of students on the new Rural Science course at the University of New England at Armidale, NSW. The sciences underlying animal production greatly appealed to her and led her to do a PhD at Cambridge University, as one of the first Commonwealth Scholars. After this she spent 17 years researching into the immune response to parasites, mainly nematodes, at the National Institute for Medical Research in London (NIMR). After spending a sabbatical year running the tropical medicine research portfolio at the Wellcome Trust she left NIMR in 1979 to co-ordinate the Trust's Tropical Medicine Programme and became its Director from 1991–8 overseeing its huge growth including increased funds for "public engagement with science". In 1993 she was the only woman appointed to the Council of Science and Technology.

Since retiring, Dame Bridget has continued to play a significant role in public engagement with science and science in education. As both a trustee of the Science Museum and chair of the AstraZeneca science teaching trust, she was also chair of COPUS, the former Committee on the Public Understanding of Science, and Techniquest. In the 1996 New Year Honours List, she was made a Dame Commander of the Order of the British Empire and in 2003 became a Fellow of the Royal Society. She was the first Chairperson of the MMV (Medicine for Malaria Venture) Board, was awarded the Companion of the Order of Australia, Australia's highest distinguished service award. Throughout her work, Dame Bridget has stressed the need for science, industry and not-for-profit concerns to work together.

Fiona Phillips

GMTV Presenter

Fiona is best-known as presenter of top breakfast show, GMTV and is one of the country's most popular faces. Born in Canterbury in 1961 and educated in Southampton, Fiona graduated from Birmingham University with a BA (Hons) in English. She gained a Post Graduate Certificate in radio journalism, before starting at local stations County Sound, Hereward Radio and Radio Mercury. Fiona joined BBC's South and East Weekend Programme as co-presenter, then moved to Sky News as a reporter, becoming Sky's entertainment's editor. She joined GMTV at the beginning of 1993 as entertainment correspondent and was promoted to GMTV/Reuters Television's LA correspondent in December 1993. For over two years she covered stories including the LA earthquake, the OJ Simpson trial and the Oscars. In 1996 Fiona was nominated for the Royal Television Society Interview of the Year Award. Fiona has presented ITV1 shows including *OK! TV, Rich and Famous* and daytime's *Loose Women* and *Baby House*. She has appeared on *Paul O'Grady, Never Mind the Buzzcocks, Ant and Dec's Saturday Night Takeaway, Question Time* and the third series of *Strictly Come Dancing* with the infamous Brendan Cole. Fiona has written for *The Sunday Express, Baby and You* magazine and *Family Circle*, and currently writes for *The Daily Mirror* and *Now Magazine*.

Fiona is the Tesco Celebrity Mum of the Year, and was voted The World's Sexiest Female Vegetarian by animal charity PETA!

In November 2007 Fiona was awarded an Honorary Master of Arts Degree by Southampton Solent University, and made headlines when it was reported she was offered a Government post by Prime Minister Gordon Brown!

Her charity interests include Breakthrough Breast Cancer, Breast Cancer Care and Plan International, and she is patron of The Alzheimer's Society, Barnardos, Age Concern, and Richard House Hospice. She is married with two sons: Nathanial, born in 1999 and Mackenzie, born in 2002.

Describe yourself in 5 words.
Describing myself is too self-indulgent (that's five words).

What are your top 5 to 10 survival tips?
Always look on the bright side of life. Believe that everything happens for a reason. Drink 2 litres of water a day, but not before bed. Ban envy and jealousy from your life. Lots of cuddles with my children. Be kind to other people, it's really good for your soul.

What is your favourite work of art?
I treasure my children's paintings and drawings. I love Lucian Freud's 'A Writer'

What is your biggest obstacle that you have faced?
Self-consciousness, although you wouldn't believe it.

What is your favourite word or words?
Mum – because it evokes so many things: childhood, security, warmth and complete, unconditional love.

Do you have a female role model?
My very smiley mum, who always treated everyone the same. When we were children she was always my friends' favourite mum too, because she was interested in them and made them feel special.

Who would you ask to a dinner party from history?
Thomas Hardy's Sue Bridehead from Jude the Obscure. Martin Luther-King. Nelson Mandela. Mick Channon, the Southampton and England footballer who was my hero in the 70s, and the two Sylvias–Pankhurst and Plath, for obvious reasons.

How did you get to where you are?
Hard Work. Dealing with rejection by being even more determined to prove everyone wrong. No clock-watching. Putting the nature of the job before the money. And good luck.

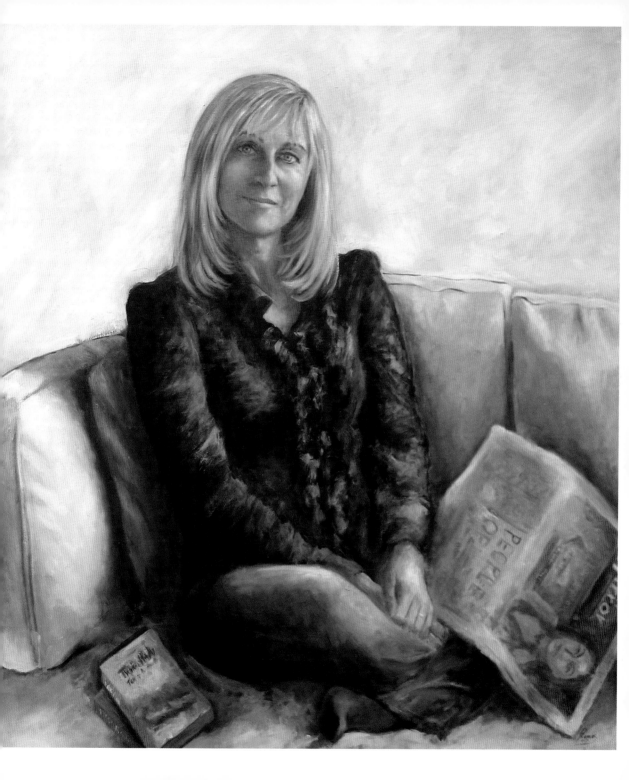

Caroline Plumb

CHIEF EXECUTIVE FRESHMINDS, RESEARCH AND
RECRUITMENT COMPANY

Caroline is CEO of FreshMinds, the research and recruitment company she founded with Charlie Osmond in September 2000 straight after graduating from Oxford. With almost no experience of working life and a limited set of contacts beyond their Oxford peer group, the duo set up an unrivalled network of 'Minds', the brightest executives, MBAs and graduates in Europe, and were able to match them to corporate clients with appropriate research or recruitment needs. In December 2000, just seven months after the launch, they accepted one-off funding in return for a 20 per cent stake in the business, a deal that provided welcome business advice and legal support from their investors. In 2006 FreshMinds won Best Agency and Most Innovative Employer in the Market Research Society Awards.

Caroline was born in Manchester in 1978 and gained a first class degree in Engineering, Economics and Management from Oxford University. While at university, Caroline was sponsored by the Government Communication Headquarters for three years, and later worked as an analyst at Fletcher Research (now Forrester Research) before co-founding FreshMinds. In 2004 Caroline spoke alongside Bill Gates and Sir Terry Leahy at Gordon Brown's Enterprise Conference and was selected as part of the UK delegation for the International Young Leaders Conference in Moscow. Caroline is on the board of the National Council for Graduate Entrepreneurship, the business advisory forum for the Said Business School Oxford, the Small Business Forum and George Osborne's Enterprise Council.

Describe yourself in 5 words.
Optimistic, inquisitive, determined, family-focused, entrepreneur.

What are your top 5 to 10 survival tips?
Seeking advice is a strength not a weakness. Sometimes if you don't ask you don't get. If you never make mistakes you're not taking enough risk. Surround yourself with positive people. And if things look bleak remember that the darkest hour is just before dawn!

What is your favourite work of art?
Anything by Rothko.

What is your biggest obstacle that you have faced?
Cynicism.

What is your favourite word or words?
Serendipity.

Do you have a female role model?
My grandma.

Who would you ask to a dinner party from history?
Marco Polo.

How did you get to where you are?
It very much feels like I'm not 'there' yet but still on the way. I really enjoy the journey and I'm sure that it will all work out well in the end, even if there might be obstacles to go over/around/through to get there.

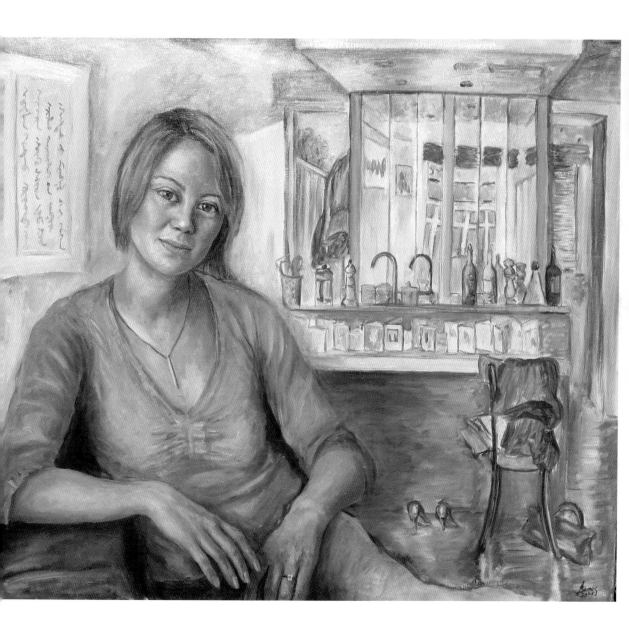

Heather Rabbatts CBE

EXECUTIVE DEPUTY CHAIR OF MILLWALL FC

Heather was born in Kingston, Jamaica in 1955 and came to England at the age of three. She studied at the London School of Economics and became a barrister in 1981. From 1987, she worked in local government, until 1989 when she became Deputy Chief Executive of Hammersmith and Fulham. She then became Chief Executive of Merton before becoming Chief Executive of Lambeth in 1995 until 2000. Advertised as the 'worst job in local government', her task was to get the Borough out of absolute crisis and she transformed it into the success it is today with improvements in housing, education and council tax collection.

Upon leaving Lambeth, Heather became Chief Executive of iMPOWER, a public sector consultancy which she founded to provide strategic consultancy to national and local government, focused on the use of new technologies to improve citizens' access to services. She subsequently became co-chair of iMPOWER and moved on to be Managing Director of Channel 4's education programmes and business, 4Learning. Her first major commission was *Twelfth Night*, followed by *Teen Big Brother* and the Emmy-Award winning *Illustrated Mum*. Rabbatts was a Governor of the BBC from 1999 to 2001, resigning upon her appointment to Channel 4. She is a Governor at the London School of Economics, an Associate of The King's Fund and on the Board of directors at the British Council.

She was awarded the CBE in the 2000 New Year Honours list. On 3 May 2006 Rabbatts was appointed as the new Executive Deputy Chair of Millwall FC and on 27 October 2006 she was appointed as Executive Chairwoman of Millwall Holdings plc. She is now also on the board of the UK Film Council.

Describe yourself in 5 words.
Resilient mixed race woman.

What are your top 5 to 10 survival tips?
Don't give up.
Seek guidance and support.
Enjoy life.
Stay true to your values.
Have a cuddle.

What is your favourite work of art?
Clement McAleer–Painting of the Irish sea.

What is your biggest obstacle that you have faced?
Trying to run a football club.

What is your favourite word or words?
Triumph.
Against the odds.

Do you have a female role model?
My mum.

Who would you ask to a dinner party from history?
Jane Austen.

How did you get to where you are?
Hard work and support from family and friends.

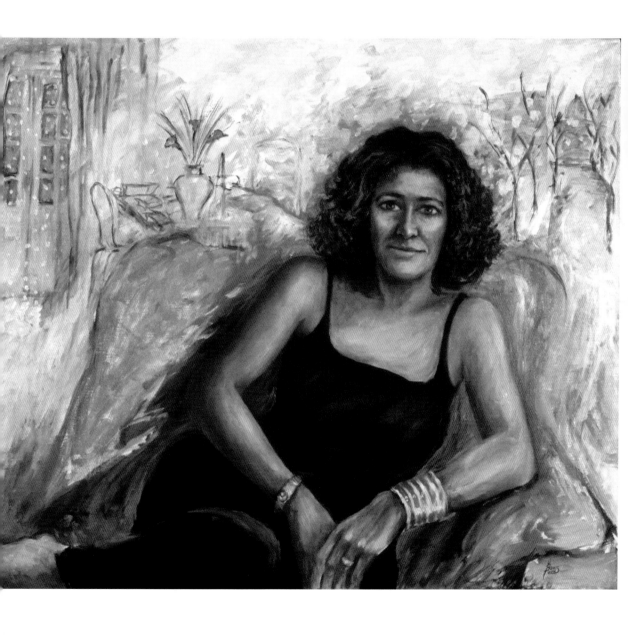

Gail Rebuck CBE

CHIEF EXECUTIVE, RANDOM HOUSE

Gail was the first woman to crack the publishing industry in the UK, publishing some of the world's best known authors, from Ian McEwan, Martin Amis and Philip Roth to Ruth Rendell, John Grisham, Dan Brown and Bill Bryson. She has published the political memoirs of President Clinton and Alastair Campbell's diaries and recently acquired Tony Blair's memoirs. She was born in London in 1952 and read Intellectual History at the University of Sussex where she was an active feminist. She applied for a job at Amnesty International but was turned down, so she began her working life guiding American students around Europe, then became a production assistant to a book packager.

At 24, she launched a mass-market paperback imprint for Hamlyn. Just before her 30th birthday Anthony Cheetham founded Century Publishing and invited Gail to join him. Starting with a phone and a desk, they built a business which took over the far bigger Hutchinson. It was then bought by Random House. In 1991 she was appointed Chairman and Chief Executive of Random House. Gail was a Trustee of the Institute for Public Policy Research from 1993 to 2003 and was for three years a member of the Government's Creative Industries Task Force.

She is a Non-Executive Director of BSkyB, on the Board of The Work Foundation, the Advisory Board of the Cambridge Judge Institute, the Council of the Royal College of Art and a trustee of the National Literacy Trust. She was instrumental in setting up the publishing industry's charitable initiative World Book Day (1997) and more recently, the Quick Reads, (which she chairs), publishing a series of short books targeted at the nation's 12 million adults with poor literacy skills. Awarded a CBE in the 2000 New Year's Honours List, she married Philip Gould in 1985 and they have two grown-up daughters, Georgia and Grace, both at university.

Describe yourself in 5 words.
A passionate book lover.

What are your top 5 to 10 survival tips?
Follow your instincts.
Never stop worrying.
Never give up.
Learn from your mistakes and have the courage to take risks.
Don't play politics and discourage it in others.
Build up trusting and confident teams – and listen to them.
Be passionate about everything you do.

What is your favourite work of art?
Odalisque with a Turkish Chair, Matisse.

What is your biggest obstacle that you have faced?
Trying to do it all.

What is your favourite word or words?
Terrific – most overused I'm afraid.

Do you have a female role model?
My mother and 2 daughters.

Who would you ask to a dinner party from history?
Jane Austen, Elizabeth I, Virginia Woolf, Freya Stark and Simone de Beauvoir – should make for a lively evening.

How did you get to where you are?
No great plans – just hard work, determination, getting on with things and enjoying every minute of it!

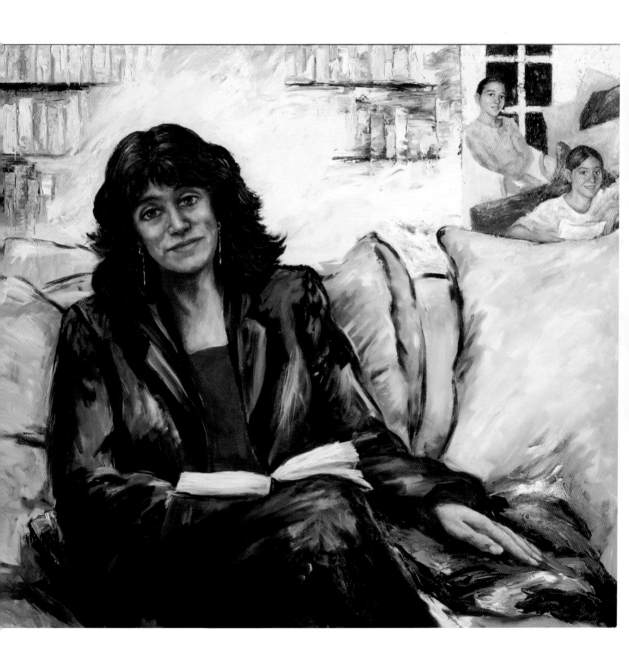

Zandra Rhodes CBE

FASHION AND TEXTILE DESIGNER

Zandra was born in Kent in the 1940s. Her mother had been a fitter in a Paris fashion house and taught at Medway College of Art. Zandra studied at Medway and then at the Royal College of Art in London, specialising in textile design.

Her textile fashion designs were considered outrageous by British manufacturers, so in 1969, she established her own outlet in West London's fashionable Fulham Road. With her colourful, theatrical hair, makeup and jewellery, her image and lifestyle proved equally extrovert.

She was one of the new wave of British designers who put London at the forefront of the international fashion scene in the 1970s. Her designs are always dramatic yet graceful, bold yet feminine. Zandra's inspiration comes from organic material and nature. Her innovations included exposed seams and use of jewelled safety pins and tears during the punk era.

Zandra has designed for Royalty including the late Princess of Wales and the rich and famous around the world. She has a cult following in the USA. She has many academic and professional honours, including six Doctorates. She is a Royal Designer for Industry in the UK and was made a Commander of the British Empire by the Queen in 1997. San Diego is her second home and the San Diego Opera commissioned her to design the costumes for *The Magic Flute* in 2001. She went on to design sets and costumes for *The Pearl Fishers* (Bizet) seen in San Diego, San Francisco, Detroit and New York City, followed by *Aida* at the English National Opera (London) and Houston Grand Opera. Her work from the late 1960's and early 1970's is a major influence on the print designs seen in the Paris and Italian collections. Zandra is the founder of the Fashion and Textile Museum in London.

Describe yourself in 5 words.
Colourful, dynamic, exotic, workaholic, larger than life.

What are your top 5 to 10 survival tips?
Belief in my work.
Never give up.
Never go out without make-up.
Upkeep of my pink hair.
When in doubt dress up to the nines.
Always wear your favourite jewellery.

What is your favourite work of art?
Monet's Waterlilies.

What is your biggest obstacle that you have faced?
Building the Fashion & Textile Museum in London.

What is your favourite word or words?
Onomatopœia.

Do you have a female role model?
Diana Vreeland.
Edith Sitwell.
Louise Nevelson.

Who would you ask to a dinner party from history?
Cleopatra.

How did you get to where you are?
Hard work and marvellous friends.

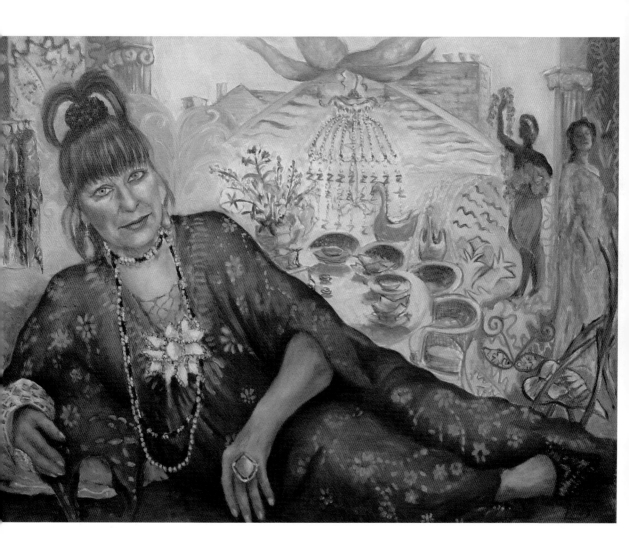

Dame Stella Rimington DCB

FIRST WOMAN DIRECTOR GENERAL OF MI5 1992—1996

Stella Rimington was formerly Director General of MI5. She joined MI5 in 1967 as a part time clerk/typist and retired in 1996 as Director General, the first woman to hold the post and the first Director General to be publicly named on appointment. Having joined when the Service's focus was dictated by the Cold War, as she rose to the top she had to deal with the changes brought about by the end of the Cold War and the rise of terrorism.

More recently she was Non-Executive Director of Marks & Spencer from 1997 to 2004 and of BG Group until May 2005. Amongst other appointments she has been Chairman of the Institute of Cancer Research, a Trustee of the Royal Marsden Hospital NHS Trust and a Trustee of the Royal Air Force Museum. She is currently a Trustee of the charity Refuge. She is now pursuing a career as a mentor, a motivational speaker and an author, having published her autobiography 'Open Secret' in 2001 and three novels, 'At Risk', 'Secret Asset', and 'Illegal Action'.

Stella Rimington was made Dame Commander of the Bath in 1996. She has received Honorary Degrees from Nottingham, Exeter, London Metropolitan and Liverpool Universities. She has two daughters and two grand daughters.

Describe yourself in 5 words.
Mother, granny, intelligence-officer, author, speaker or (if you want physical appearance) Tallish, fattish, oldish, greyish, calmish.

What are your top 5 to 10 survival tips?
Don't take yourself too seriously.
Keep calm–outwardly at least.
Don't expect to do everything perfectly–no-one can–so be prepared to make compromises.
Seek advice from those you respect, then make your own mind up.
If you need to be ruthless (and you sometimes will), disguise it with charm.

What is your favourite work of art?
The Arnolfini Portrait *by Jan van Eyck.*

What is your biggest obstacle that you have faced?
Men.

What is your favourite word or words?
Sesquipedalian.

Do you have a female role model?
No.

Who would you ask to a dinner party from history?
Queen Elizabeth I.

How did you get to where you are?
By hard work, perseverance and taking opportunities when they came along.

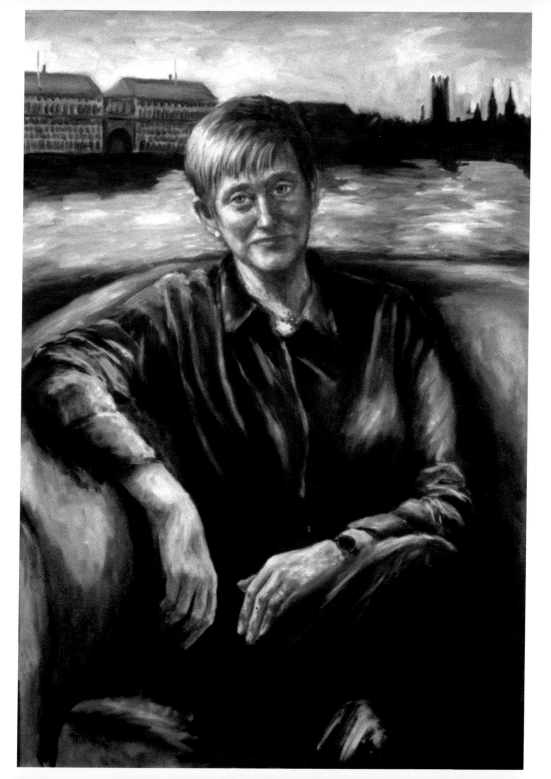

June Sarpong MBE
TV Presenter, Journalist

June was born in London in 1977. Her Ghanaian parents separated when she was seven and she was raised by her mother, a nurse, in Leytonstone. June's brother is Sam, an actor and MTV host and she has a sister Becky. After an A Level in Performing Arts, June began her media career with Kiss FM and later became an MTV UK and Ireland presenter on *Dance Floor Chart, Weekend Edition,* and *Select* with Richard Blackwood. She has been a face of Channel 4's *Sunday morning T4* for the last six years, interviewing Tony Blair for a *T4* special, *When Tony Met June* in January 2005.

She runs her own production company, Lipgloss Productions. Projects in development include a sitcom and a programme on climate change. In recent years, June has presented *Your Face Or Mine?* a game show with Jimmy Carr for E4; *Dirty Laundry,* her own concept urban talk show; *Playing It Straight,* a dating game show filmed in Mexico for Channel 4 and ITV2's *WAGs Boutique.* June has presented the *Smash Hits Poll Winners Party* and the *Party In The Park* and has presented the MOBO Awards for three years in a row. She has appeared on *Question Time, Have I Got News For You, Never Mind The Buzzcocks* and reported on youth culture for *This Week.* June is an ambassador for The Prince's Trust and in April 2005 she filmed in Ghana for *Make Poverty History,* before hosting the campaign's event in London's Trafalgar Square in summer 2005 on behalf of Nelson Mandela and Sir Bob Geldof. She is an ambassador for Our Leaving Care initiative, which provides mentors and support for young care leavers. She was awarded an MBE in the 2007 New Year Honours List for 'Services to Broadcasting and Charity', for her work with The Prince's Trust.

Describe yourself in 5 words.
Fun, strong, smart, girlie, honest.

What are your top 5 to 10 survival tips?
Never take no for an answer, where there's a will there's a way.

What is your favourite work of art?
Chris Ofilli, No Woman, No Cry.

What is your biggest obstacle that you have faced?
Racism – but there's nothing more rewarding than breaking barriers.

What is your favourite word or words?
Wow!

Do you have a female role model?
Oprah Winfrey.

Who would you ask to a dinner party from history?
Ghandi, Martin Luther King and Bill Gates.

How did you get to where you are?
Hard work, being thick skinned and a keen interest in people.

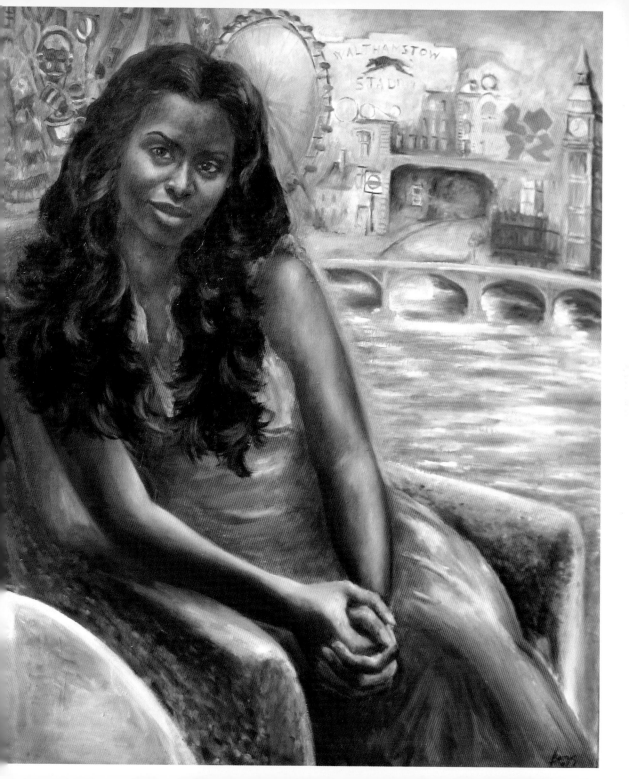

Baroness Patricia Scotland QC

The Attorney General

The Rt Hon the Baroness Scotland of Asthal QC was appointed Attorney General on 28th June 2007 from the Home office where she had been Minister of State for the Criminal Justice System and Law Reform and, from May 2005, the Minister for the Criminal Justice System and Offender Management. After graduating with LLB Hons (London), Patricia Scotland was called to the Bar, Middle Temple, in 1977, received Silk in 1991 and became a Bencher in 1997. She is an Honorary Fellow of The Society for Advanced Legal Studies; Wolfson College, Cambridge and of Cardiff University. She has Honorary Doctorates from the Universities of Westminster, Buckingham, Leicester and the University of East London. She is a Dame of the Sacred Military Constantinian Order of Saint George. She was awarded Peer of the Year in the House Magazine 2004 Awards, Peer of the Year in the Channel 4 Political Awards 2004, Parliamentarian of the Year in the Political Studies Association Awards 2004 and The Spectator Parliamentarian of the Year Awards 2005. She is a patron of The Margaret Beaufort Institute, GAP and is on the Advisory Panel of the British American Project. She is a member of the Thomas More Society, the Lawyers' Christian Fellowship and the Lords Prayer Group. She has specialised in family and public law and has chaired Inquiries relating to Child Abuse, Mental Health and Housing. She was voted Black Woman of the Year (Law) 1992. Baroness Scotland was created a peer as Baroness Scotland of Asthal, of Asthal in the County of Oxfordshire, in 1997 and was raised to the Privy Council in July 2001. She married in 1985 and has two sons.

Describe yourself in 5 words.
Aspirational.

What are your top 5 to 10 survival tips?
Pray.

What is your favourite work of art?
People–living art.

What is your biggest obstacle that you have faced?
Myself.

What is your favourite word or words?
Auspicious.

Do you have a female role model?
My mother.

Who would you ask to a dinner party from history?
Touissan L'Ouvert.

How did you get to where you are?
With difficulty.

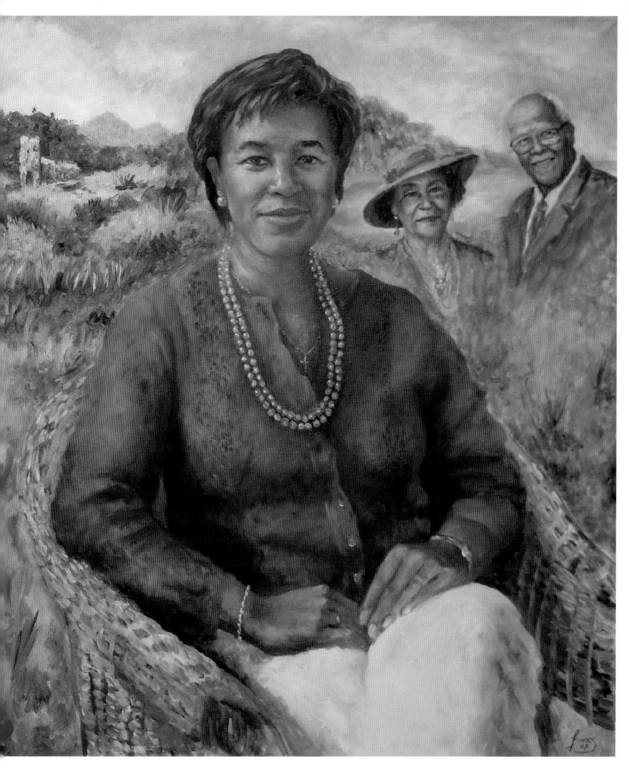

Lesley Sharp

Actor

Lesley Sharp was born in Manchester. She trained at the Guildhall School of Music and Drama. She has worked at the Royal Court Theatre, the National Theatre, The Royal Shakespeare Company and for Cheek by Jowl. She has been nominated twice for an Olivier award. Television work includes *Clocking Off, Bob and Rose, The Second Coming, Afterlife* and many other single dramas. She has been nominated several times for BAFTA and has been nominated for and won two royal television society awards, a press guild award and 2 awards from the Monte Carlo television festival for her work in *Bob and Rose* and *Afterlife*.

Film work includes the cult movie *Rita Sue and Bob Too*, directed by Alan Clarke, *Naked* and *Vera Drake* directed by Mike Leigh, *The full Monty* and *Inkheart*, released summer 2008.

She will be appearing at the National Theatre in spring 2008 in the world premiere of Simon Stephens play *Harper Regan*, directed by Marianne Elliot.

Describe yourself in 5 words.
Surprised, hungry, deliberate, longsighted, alive.

What are your top 5 to 10 survival tips?
Always carry an avocado in your pocket.
Cultivate exquisite manners.
Keep your friends close but your enemies closer and movie people up your ass.
Learn to bake.
Know your way home.

What is your favourite work of art?
5 Angels of the Millennium *by Bill Viola*

What is your biggest obstacle that you have faced?
Lack of beauty.

What is your favourite word or words?
Shall, lunar, iridescent, lunch, heterodox

Do you have a female role model?
Olga Korbut.

Who would you ask to a dinner party from history?
My Dad, Carl Jung, Eric Morecambe, my Mum, James Stewart.

How did you get to where you are?
Train from Manchester Piccadilly to London Euston.

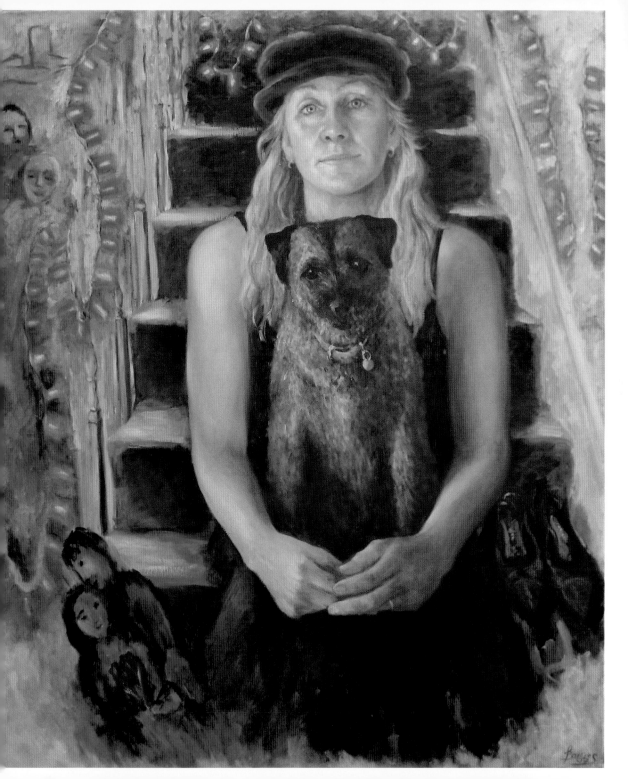

Carole Stone

BROADCASTER AND WRITER. MANAGING DIRECTOR OF
THE OPINION RESEARCH COMPANY, YOUGOVSTONE

Carole has had an extensive career in the media, working for the BBC for over twenty years, many of these as the Producer of its flagship current affairs Radio 4 programme, *'Any Questions?'* Since then Carole has published two books: *'Networking–the Art of Making Friends',* and *'The Ultimate Guide to Successful Networking'.*

Born in 1942, Carole became a BBC secretary after taking classes at the Lucy Clayton Charm School, where she learned how to overcome her shyness and get into a car elegantly ('bottom in first, knees together, swing in!). After working in local radio she became a network radio producer at the BBC in Bristol, where she worked on *'Woman's Hour'* and *'Down Your Way'.* It was here that she began to build up her legendary contacts book which has since earned her the title 'the queen of networking'.

In 1990 Carole left the BBC to work as a freelance reporter and producer and also began hosting informal lunches in her flat in London's Covent Garden. These were the precursor to her now legendary Monday evening salons where she likes to bring together people from the worlds of media, business, the arts and politics who might otherwise never have met.

A former President of The Media Society, Carole has served on the committee of Women in Journalism and has been made a life member of the London Press Club. She is a Trustee of The Wallace Collection, patron of two mental health charities, and a partner in the London debating forum Intelligence Squared. In 2007 Carole became the Managing Director of YouGovStone, a joint venture company with the online opinion research agency YouGov. She has now formed the YouGovStone ThinkTank of 'influentials', opinion leaders whose views contribute to the debate on issues that affect us all.

Describe yourself in 5 words.
I am passionate about people.

What are your top 5 to 10 survival tips?
Take a leap of faith, don't worry about failure, always look around the next corner, prioritise, aim high and hold the aim.

What is your favourite work of art?
The Resurrection *by Piero della Francesca in Sansepolcro, Italy.*

What is your biggest obstacle that you have faced?
Being a drama queen.

What is your favourite word or words?
'All shall be well and all manner of thing shall be well' by Dame Julian of Norwich.

Do you have a female role model?
My Mother.

Who would you ask to a dinner party from history?
The Marquise de Sévigné, who wrote the most wonderful letters to her daughter.

How did you get to where you are?
Persistence and Optimism.

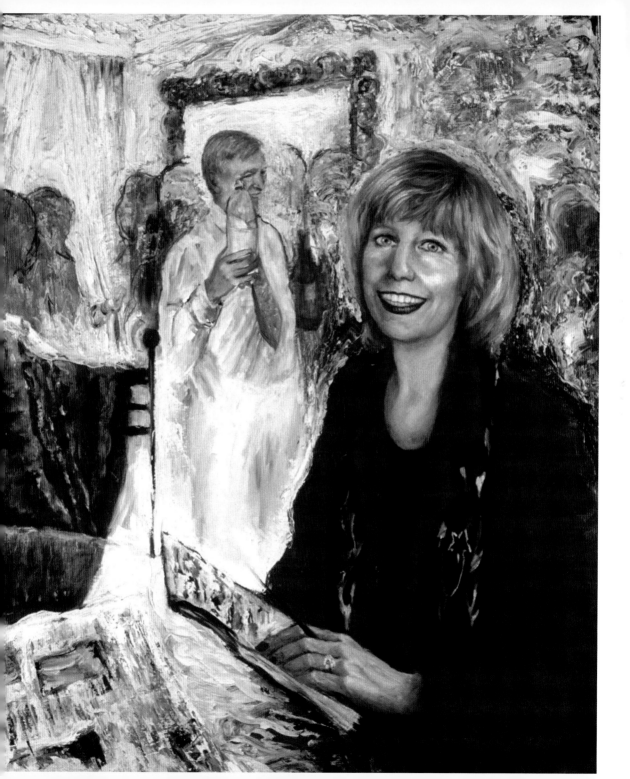

Dame Tanni Grey Thompson DBE OBE

PARALYMPIC ATHLETE AND RECORD GOLD MEDAL WINNER

Dame Tanni is Britain's best-known paralympic athlete, having performed at world-class level, in distances ranging from 100m to the London Marathon. Tanni's career has taken her around the world to every major international event. Her 15 Paralympic medals including 11 golds, six gold medals in the London Marathon and her comprehensive set of British and World Records make her achievements second to none in the disability sport arena.

Born in Cardiff in 1969, Tanni was named Carys Davina, however, when her sister first saw her she called her 'tiny' which stuck and she became Tanni. Born with spina bifida, she always strove to be independent, attending her local primary school, at first using crutches and callipers, and then a wheelchair. She progressed to St. Cyres Comprehensive School and subsequently obtained an Honours Degree in Politics at Loughborough University. Tanni has been named BBC Wales Sports Personality of the Year three times and in 2000 she was decorated with the OBE in honour of her services to sport.

In 2004 she was awarded a Damehood. As a much loved and respected individual both on and off the track, Tanni is also an accomplished TV and radio presenter and guest. Alongside this impressive list of sporting and media achievements she has lobbied and promoted many issues and causes associated with disability sport and disability in general, resulting in improved access and understanding of the people and sports involved. Tanni now lives in Redcar with her husband, Dr Ian Thompson and their daughter Carys, who was born in February 2002.

Describe yourself in 5 words.
Focused, determined, loyal, approachable, adaptable.

What are your top 5 to 10 survival tips?
Always try to stay calm in difficult situations.
Make sure that your mobile is charged before a long journey.
Be prepared—I always travel with a change of clothes in hand luggage when flying.
Make sure that your children can dress themselves from an early age—it's a lifesaver on frantic mornings.
Always have cheese in the fridge!

What is your favourite work of art?
Monet's Waterlilies*—it's a very calming picture.*

What is your biggest obstacle that you have faced?
Probably people's perception of disability. In the past I have been ignored in shops, and some people still persist in talking to the person I am with instead of directly to me.

What is your favourite word or words?
Fantastic.

Do you have a female role model?
My mum—she was always calm in a crisis, and always gave my very good advice.

Who would you ask to a dinner party from history?
Laurel and Hardy—they make me laugh.
Lord Byron—mad, bad and dangerous to know!
Marilyn Monroe—a lot more than a 'dumb blonde'.
Jane Austen—the writer of one of my favourite books, Pride and Prejudice, *and I think she would be fascinated by Marilyn.*

How did you get to where you are?
With a lot of hard work and determination, and by striving to be the very best I can be at everything I do.

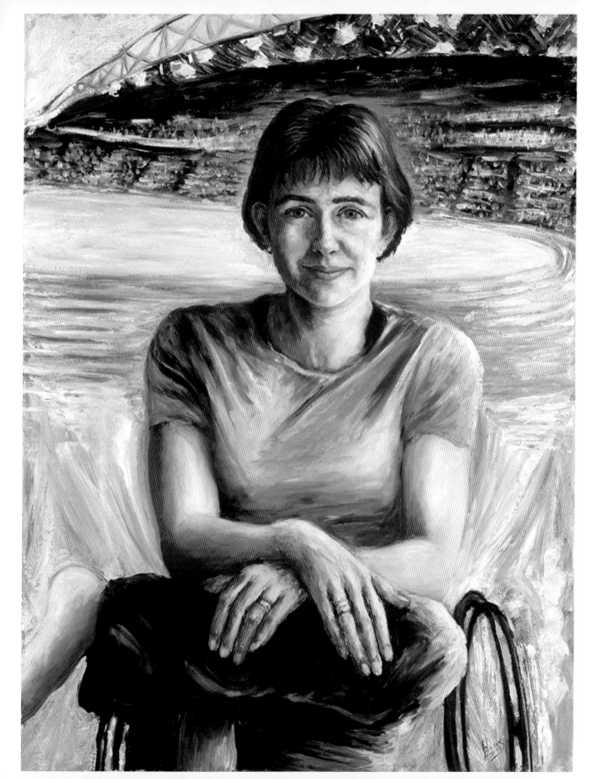

Carol Vorderman MBE

TELEVISION PRESENTER

Carol was born in 1960 in Bedford and brought up with her siblings in North East Wales by her mother. Carol was the first pupil from her Rhyl comprehensive to get to Cambridge. Aged 17, and with an IQ of 154, she gained a Bachelor degree followed by a Masters in Engineering. At 21, prompted by her mum, she applied for and won the role of statistician on *Countdown*, a game show on the new Channel 4, delighting viewers with her mathematical talent and on-screen rapport with host Richard Whiteley (who sadly died in 2005). The programme celebrated its 25th anniversary on television in 2007 and has become a British institution.

Since then she has become one of the most successful females on British television, presenting many shows including *Tomorrow's World*, moving to ITV in 1999 to present, among others, *The Pride of Britain Awards* (since 2000), *Better Homes and Better Gardens*. She has presented four national radio series and developed a range of educational videos and books. Carol has also had a column in *The Daily Telegraph* and *The Daily Mirror*. Her books for children include *Dirty Loud and Brilliant (science experiments)*, *How Mathematics Works* and *Carol Vorderman's Guide to The Internet*. Her book *Detox For Life* detailing her own fitness and diet regime has sold over a million copies. She has written and sold millions of sudoku puzzle books and video games worldwide. In 2007 she launched *Carol Vorderman's Mind Aerobics* together with BSkyB. She opened the New Community University of Wales in Llandudno in 2000. Carol was awarded the MBE for Services to Broadcasting in Honours List 2001. Carol recently met her estranged father and traced the Dutch side of her family as part of the BBC *Who Do You Think You Are?* She is the patron of the Cleft Lip and Palate Association (her brother, Anton, was born with a cleft lip and palate). Carol has a son Cameron and a daughter Katie.

Describe yourself in 5 words.
Stubborn, smiley, happy, wobbly, free.

What are your top 5 to 10 survival tips?
Don't just go with the flow, use your brain and go wherever you feel it should be flowing.
Well prepared is half won.
Stop moaning because it's a waste of energy and you get on everyone's nerves.
Accept the fact that you're going to be rubbish at many things and laugh cos it really is funny.
Win or lose, have some booze–that was Richard Whiteley's favourite and he had a great life.

What is your favourite work of art?
My favourite piece of art is one I found on the internet. A large piece called Daisy. *It's a gorgeous painting of a cow's head in an impressionist style by a young Irish artist called Deborah Donnelly.*

What is your biggest obstacle that you have faced?
A bad first marriage.

What is your favourite word or words?
Change. I love change. I thrive on it.

Do you have a female role model?
The women in my family.

Who would you ask to a dinner party from history?
I'd have to invite Mrs Beaton because I don't cook and she'd have to do the honours. So as well as her, probably Lady Thatcher in her early 80s heyday, Clark Gable, Pope John Paul II, John F Kennedy, Marilyn Monroe, Eric Morecambe, Les Dawson, Cassius Clay floating like a butterfly, Catherine Cookson and Mata Hari.

How did you get to where you are?
Via a comprehensive school in North Wales, Cambridge University, Yorkshire Television, Channel 4 and my mother's never ending support.

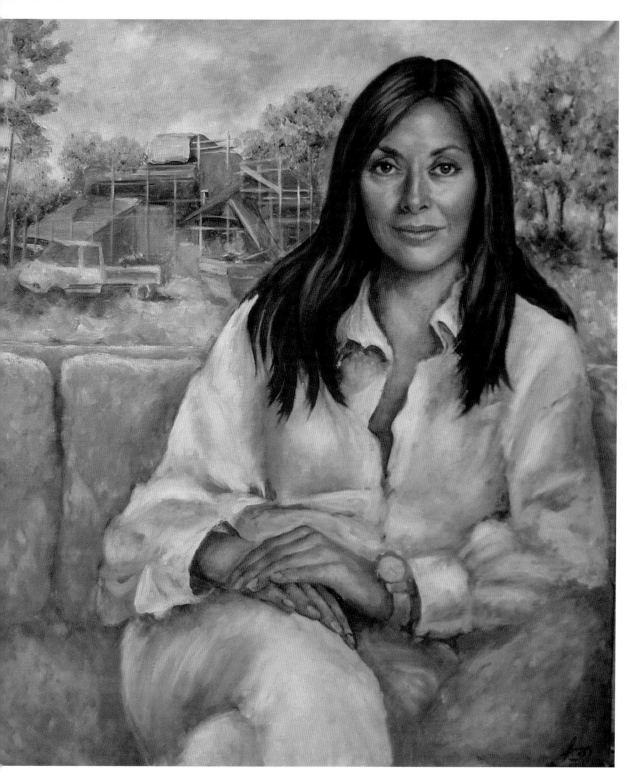

Rebekah Wade

Editor, *The Sun*

Rebekah was born in 1968 in Cheshire. She is a British journalist and newspaper editor. She is currently editor of Rupert Murdoch's *The Sun* newspaper. Having decided she wanted to be a journalist from the age of fourteen, she went to work for Eddie Shah's Messenger Group in 1989. She joined the *News of the World* in 1990 as a researcher, and rose through the ranks, first as a feature writer for its *'Sunday'* magazine, before eventually becoming the paper's deputy editor. In 1998 she transferred to the *News of the World's* weekday counterpart, *The Sun*, to become its deputy editor. She then returned to the *News of the World* in 2000 as editor; at the time, she was the youngest editor of a national British newspaper. In January 2003, she moved back to *The Sun* to become its first female editor.

Describe yourself in 5 words.
Journalist, editor, daughter, friend, housewife.

What are your top 5 to 10 survival tips?
Avoid becoming the Home Secretary; a football manager or a national newspaper editor.

What is your favourite work of art?
Lowry.

What is your biggest obstacle that you have faced?
Quit smoking.

What is your favourite word or words?
Scoop.

Do you have a female role model?
Margaret Thatcher.

Who would you ask to a dinner party from history?
Lord Lucan, Princess Diana and Shergar...to find out what really happened.

How did you get to where you are?
Sometimes the best man for the job is a woman.

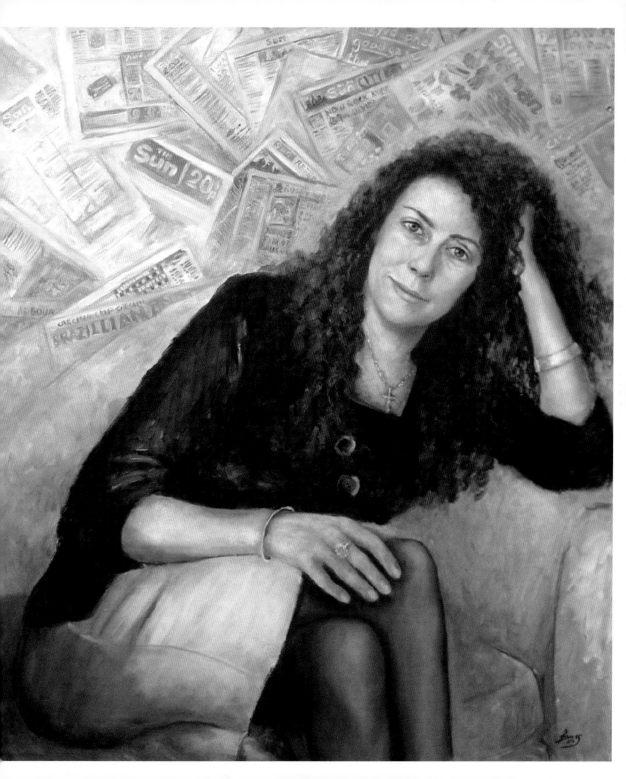

Perween Warsi CBE, MBE

CHIEF EXECUTIVE S&A FOODS LTD

Perween began her business making ethnic finger foods from her kitchen. In 1986 she founded S&A foods, (which are the initals of her two sons). She won her first major contract to supply chilled and frozen dishes to ASDA and Morrisons stores, securing the contract via blind tasting and much perseverance. In 1989 the first S&A Foods factory was built in Derby, creating over 100 jobs for the area. By 1996 the success of S&A had led to the need for larger premises, and a new bespoke factory was built next to the original site. In the same year Perween received the Woman Entrepreneur of the World award. Perween was awarded an Honorary MBA by the University of Derby and appointed to the Department of Trade and Industry Advisory Committee and Competitiveness. In the same year, Perween was awarded an MBE in the British New Year's Honours list.

In 2002, Perween received the prestigious CBE award in the Queen's Jubilee Honours list and the Ashridge International Leadership Conference accolade for outstanding leadership. She also sits on the CBI National Committee. In May 2004, Perween regained 100 per cent ownership of Derby-based S&A Foods with the acquisition of the share holding from venture capitalists 3i. She is Chief Executive of S&A foods. Most recently, Perween was awarded the First Women Lifetime Achievement Award alongside Baroness Hogg, chairman of 3i (sponsored by the CBI). What means the most to Perween are the many awards she has received for her products, ranging from quality awards to innovation awards. At the National Curry Awards in 2006, S&A Foods won the award for 'Best Chicken Tikka Ready Meal'.

Describe yourself in 5 words.

Mother, grandmother, innovative, compassionate, especially to those who are less fortunate than I am. Determined.

What are your top 5 to 10 survival tips?
*Make time for yourself, family and friends.
Respect others, especially your juniors.
Have a vision and work hard to make it reality.
Listen to advice and take criticism graciously.
Remain focused and stay calm.
Common sense and confidence go a long way
Encourage positive thinking.
Opportunity only knocks once, grab it.
Be brave–make decisions.
Have the courage and determination to overcome any obstacles that come in your way.
Never sign anything without reading it first.*

What is your favourite work of art?
I admire Picasso's work and the detail of Monet's.

What is your biggest obstacle that you have faced?
Time. Starting my business at the right time for me, and for my family.

What is your favourite word or words?
Family, happiness, good idea, how can we do it!

Do you have a female role model?
I really admired Anita Roddick very much. She was a visionary who has given so much to society.

Who would you ask to a dinner party from history?
Actually I would like to have dinner with people from the present rather than the past–my family and friends.

How did you get to where you are?
By remaining determined and setting up the company with great people and great products.

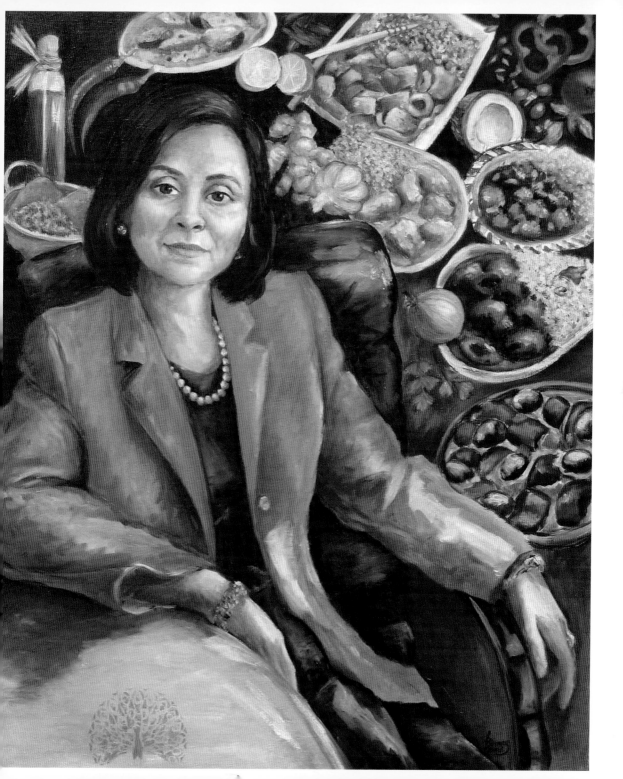

Dame Jacqueline Wilson OBE, DBE

AUTHOR

Born in Bath, Jacqueline grew up in Kingston-on-Thames. She always wanted to be a writer and filled countless Woolworths' exercise books as she grew up. She started work as a journalist for DC Thomson in Scotland where *Jackie* magazine was named after her.

Random House Children's Books publish a host of her books including *The Story of Tracy Beaker*, now a major children's drama series on CBBC. *Double Act*, *Midnight* and *Bad Girls* have been adapted for the stage and have toured the UK and Ireland. Her *"Girls"* series for slightly older readers has been a huge success both here and in the States and *Girls in Love* was a major children's drama shown on ITV. *The Illustrated Mum* starring Michelle Collins was broadcast to great acclaim on Channel 4 and has been awarded an EMMY and two BAFTAS. Jacqueline has been honoured by a special ChildLine award in recognition of her "unique insight into challenging subjects"

Jacqueline has been on countless shortlists and has won many awards, including the Smarties Prize, and the Children's Book Award. *The Illustrated Mum* won the Guardian Children's Fiction Award and the 1999 Children's Book of the Year at the British Book Awards. It was short listed for the 1999 Whitbread Children's Book Award. *The Story of Tracy Beaker* won the 2002 Blue Peter People's Choice Award.

From 2005 to 2007 Jacqueline was privileged to be the Children's Laureate during which time she led an immensely successful campaign to encourage adults to read aloud to children long after they can read for themselves. In 2004 Jacqueline Wilson became the most borrowed author from libraries across the UK, and she still is.

Over 20 million copies of Jacqueline Wilson's books have been sold in the UK and they have been translated into 34 different languages.

Describe yourself in 5 words.
I'm imaginative, hard-working, funny, anxious, eccentric.

What are your top 5 to 10 survival tips?
I make lists; get up early; think things out when I'm walking or swimming; confide worries to a close friend; relax with a glass of wine.

What is your favourite work of art?
Almost impossible to choose! I particularly love Duccio's Madonnas and Rossetti's long-haired stunners and Picasso's large pink nudes.

What is your biggest obstacle that you have faced?
You could say having to fend for myself from the age of 17 was my biggest obstacle–but it was also my greatest incentive!

What is your favourite word or words?
I love the word rainbow.

Do you have a female role model?
I'm a bit old in the tooth to have a role model.

Who would you ask to a dinner party from history?
I'd ask Virginia Woolf and Charles Dickens and Katherine Mansfield and Charlotte Bronte–and then be so overcome I wouldn't be able to think of a single thing to say!

How did you get to where you are?
I got to where I am by working very hard and not giving up–and I've also been very lucky!

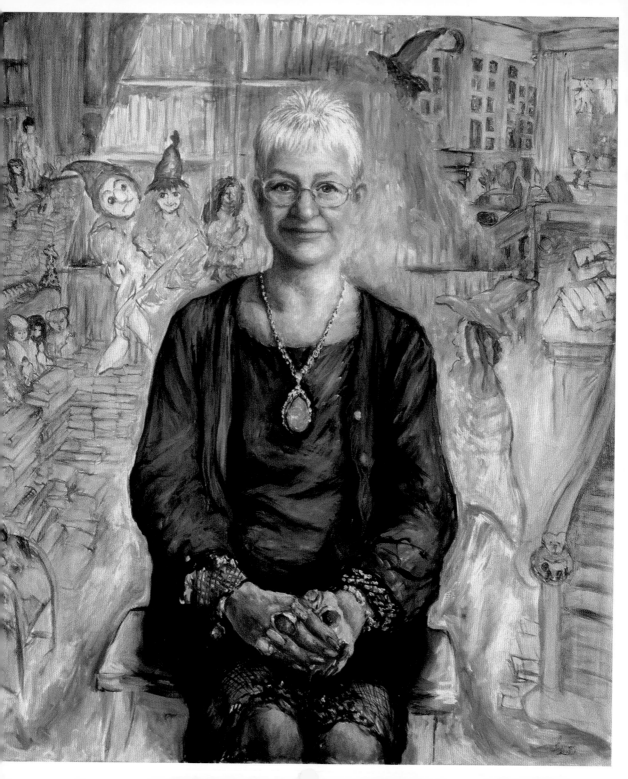

Being painted

By Sarah Kent

I receive dozens of letters from people asking for my help and, I'm ashamed to say, I ignore most of them. I have to. As a critic my job is to respond to the ideas and achievements of others but, in order to maintain some sanity, I need to reserve space and time for my own thoughts. This doesn't prevent me from feeling guilty, although, about the questions I haven't answered, the thesis I haven't helped to write or the project I haven't furthered, so when Tess Barnes wrote asking if I would sit for my portrait, I decided to meet her, at least.

There was something about her letter and follow-up call that inspired confidence – her enthusiasm was almost palpable–and her project appealed to me. She planned to paint the portraits of women working successfully in as many different fields as possible. It is about time that we acknowledged the important contributions made by women to their professions and Tess's project seemed an excellent way of making their numbers visible.

I find contemporary portraiture problematic, though. The relationship between artist and sitter is a vexed one; there are so many ways to get it wrong. Attaining the right degree of respect for the 'otherness' of the subject without appearing sycophantic or sentimental is extremely difficult and, at the other extreme, the artist's approach can seem patronising or dismissive, bullying or disinterested. The sitter often appears more exploited than celebrated–more victim than sovereign. And because, by their very nature, paintings are slow to produce and to look at, the medium seems inappropriate as a response to the speed of contemporary life. Whereas photography and video easily convey a sense of movement and vitality, paintings can often be lifeless and wooden.

Nothing prepared me, though, for the pink-haired extrovert who arrived armed with her portfolio. Tess's passion for painting and her interest in people show through in portraits that have genuine warmth and vitality; but it was her personality as much as her work that melted away my reservations. I agreed to sit for her, despite the fact that modelling is my idea of hell. I scarcely ever sit down unless I am eating or working, so posing for an hour at a stretch would require a degree of passivity completely alien to me. I also hate being scrutinised; when I was a practising artist I used to draw myself incessantly and perhaps in the back of my mind is lodged the idea that, since I haven't yet finished examining my face, I am not ready to expose it to someone else's gaze. In any case, I find images of myself embarrassing. I'm the one who contrives to be absent from the group photograph or pulls faces when I can't escape the lens.

Yet I don't regret my decision to a minute. Tess is incredibly good at what she does. Portraiture must be one of the most difficult genres to master. You have to work in company – to establish a rapport with your sitter while, at the same time, concentrating on the difficult task of making a picture that satisfies both you and your subject. Tess can capture a likeness with enormous fluency and speed and, because movement doesn't disturb her concentration, you don't have to freeze into the kind of mummy-like stasis that kills an image. She talks freely while she works and so is excellent company; she makes you relax far more ably than most interviewers or photographs whose jobs depend on putting you at your ease. I enjoyed our sessions and my pleasure shows in the final picture, I think. There's no sign of the ennui that makes bad portraits so leaden; on the contrary I seem alert and alive, as though engaging in a dialogue.

I was glad to be able to contribute in a small way to this splendid project. I wish Tess Barnes every success. She richly deserves it.